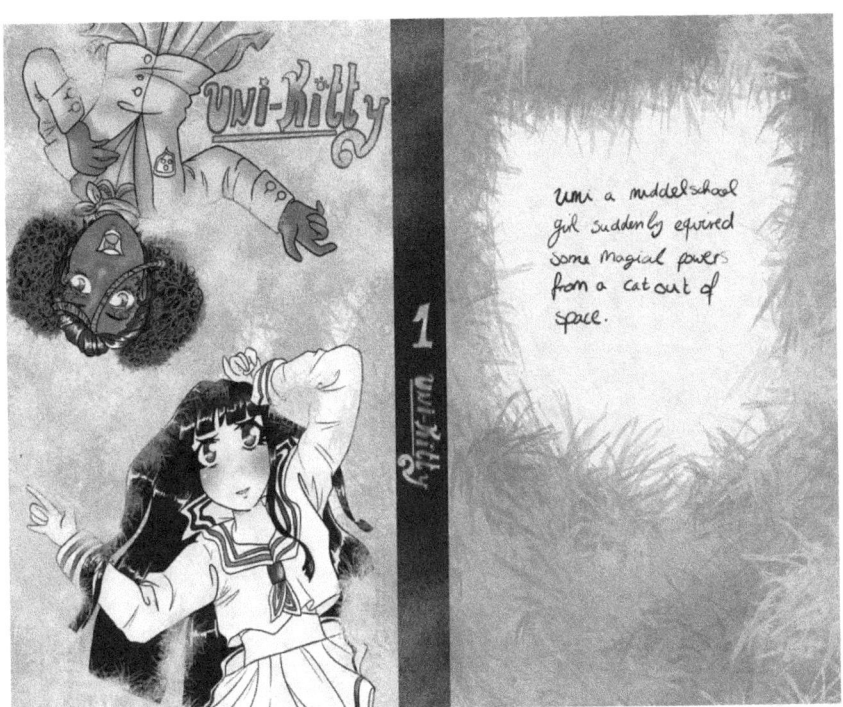

Uni-Kitty

Chapter 1 page 3-22

Chapter 2 page 23-30

Chapter 3 page 31-36

Artist note page 38

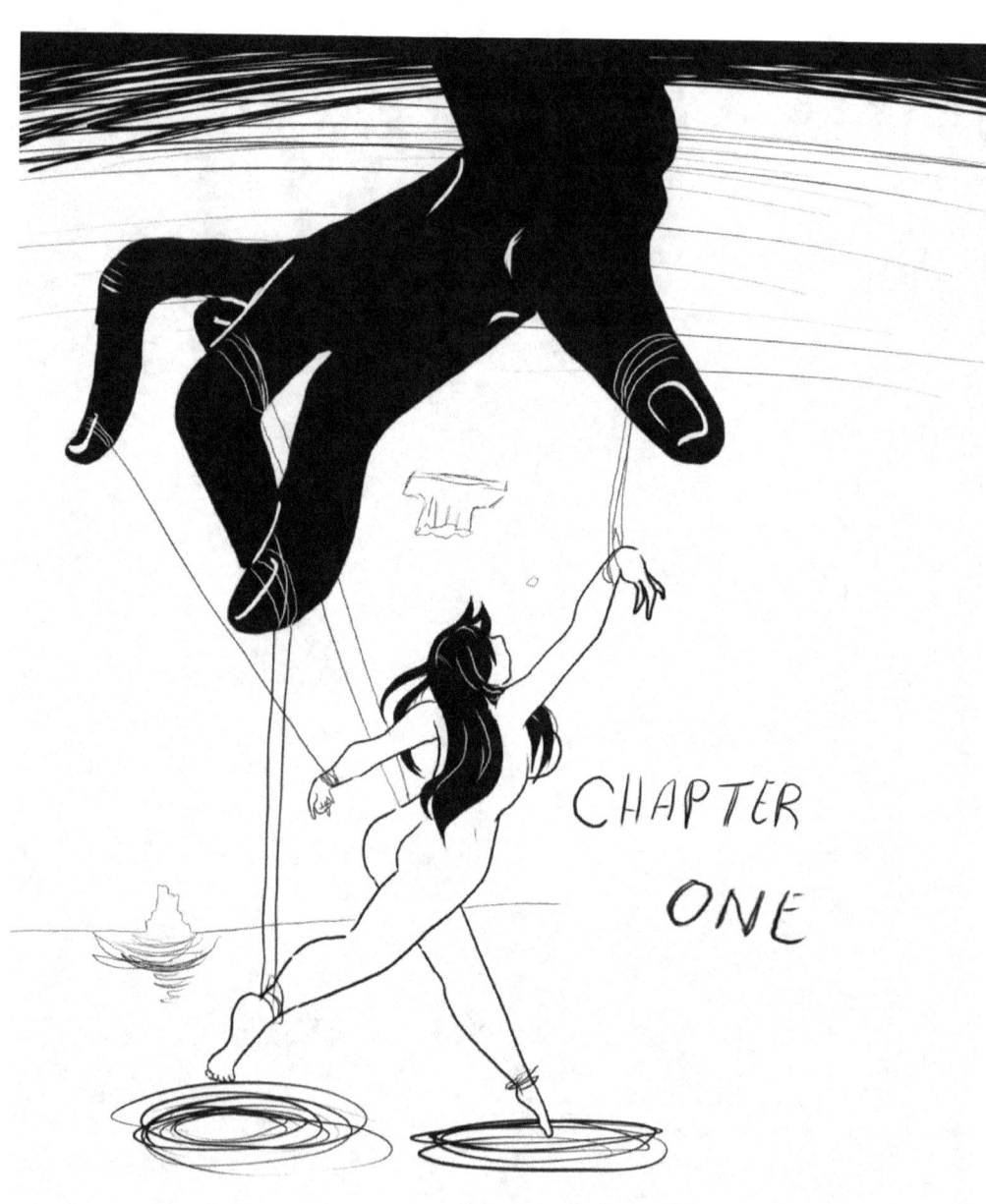

In the world of kitty, there are peopel called uni, which poses the gift of Magic...

...These gifted ones rule this planet in peace, and gift peopel deemed worthy special powers, to help in there tasks...

...and to keep their world save, there have been unique once. But one fatheful day the planets balance was shifted, by a darkness that was unfamilliar to the peopel of kitty...

...the peopel of kitty lost their beloved uni. Darkness took over and the peopel grew toward the darkness, loosing their light and peace.

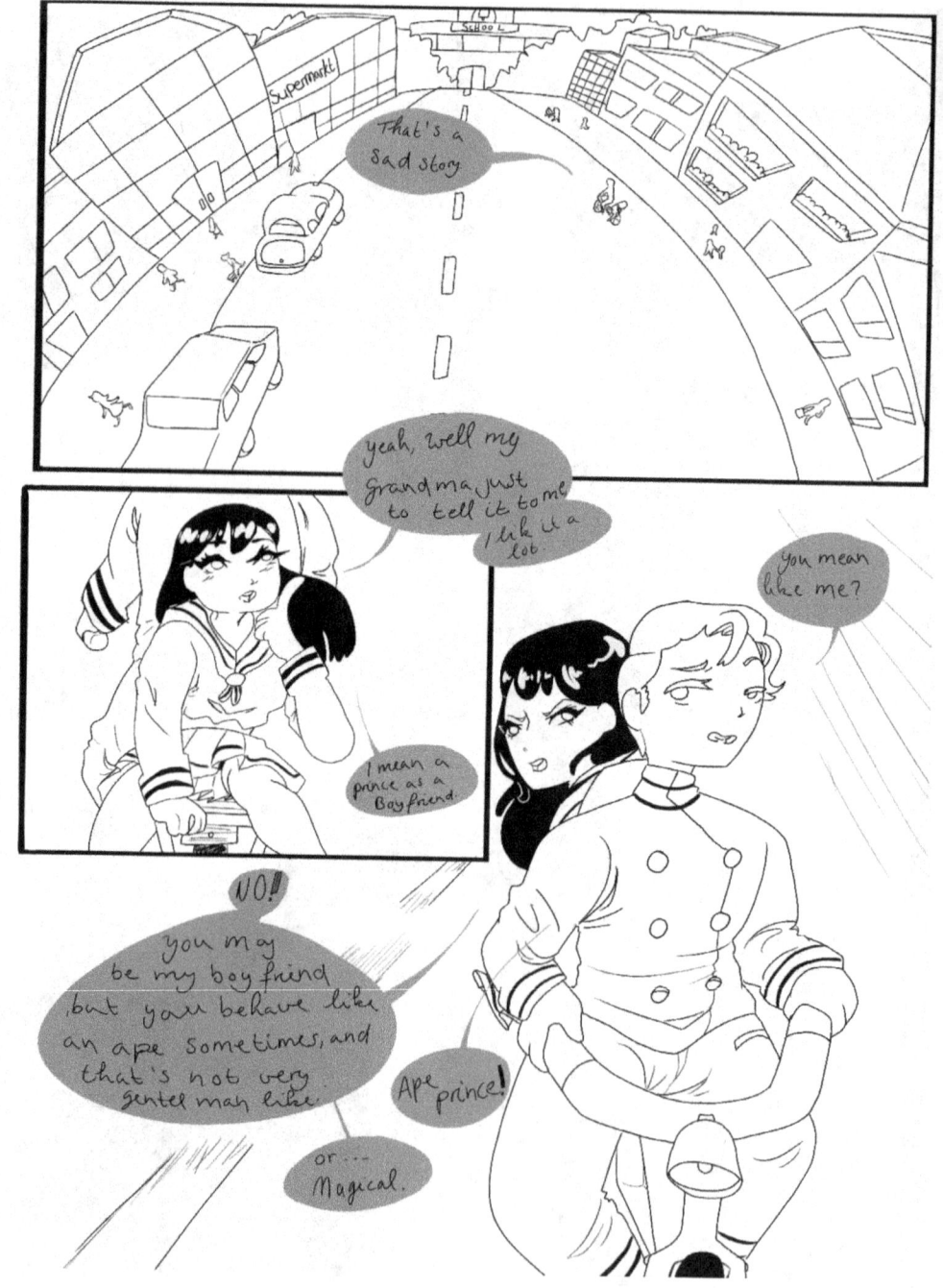

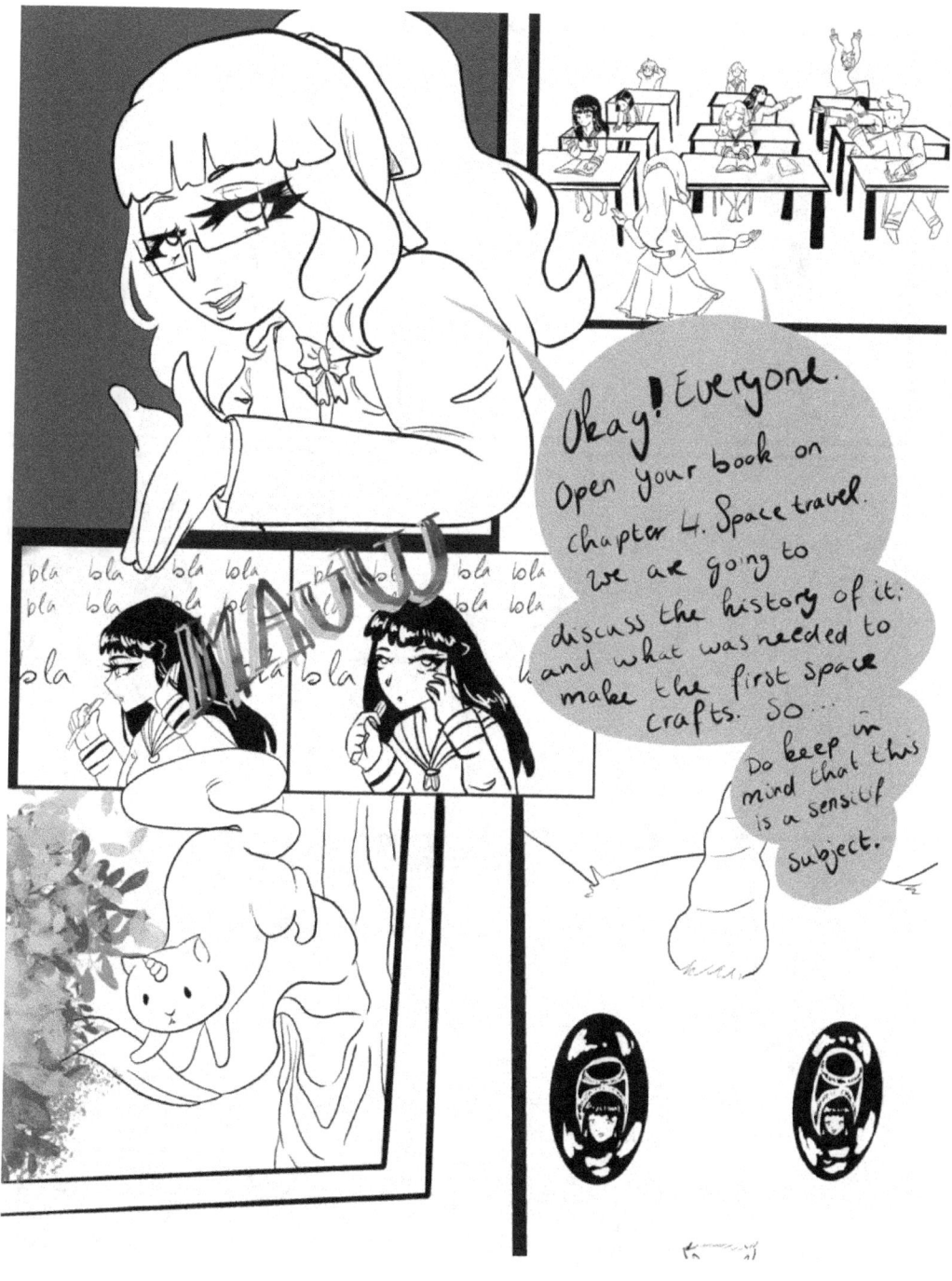

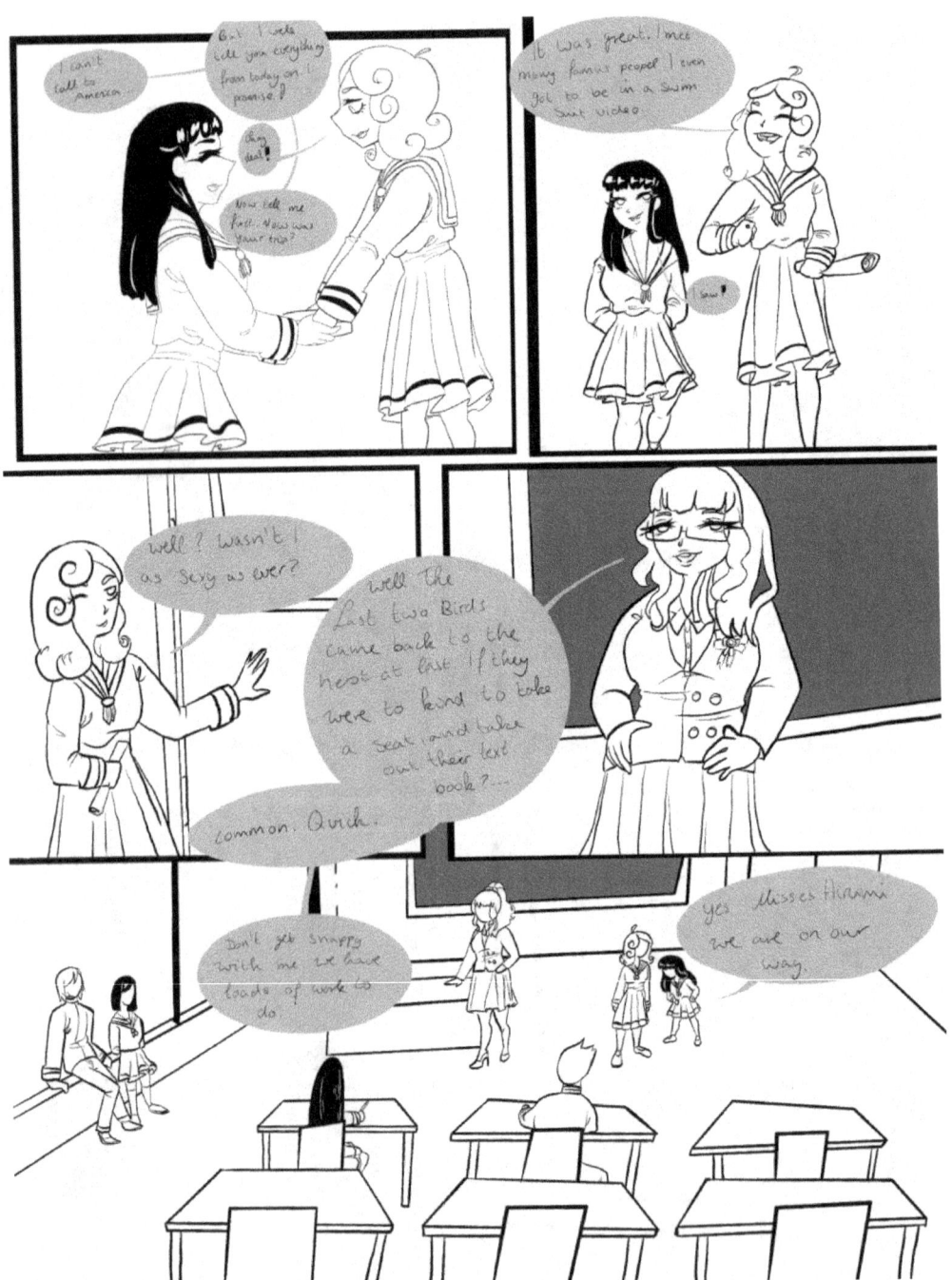

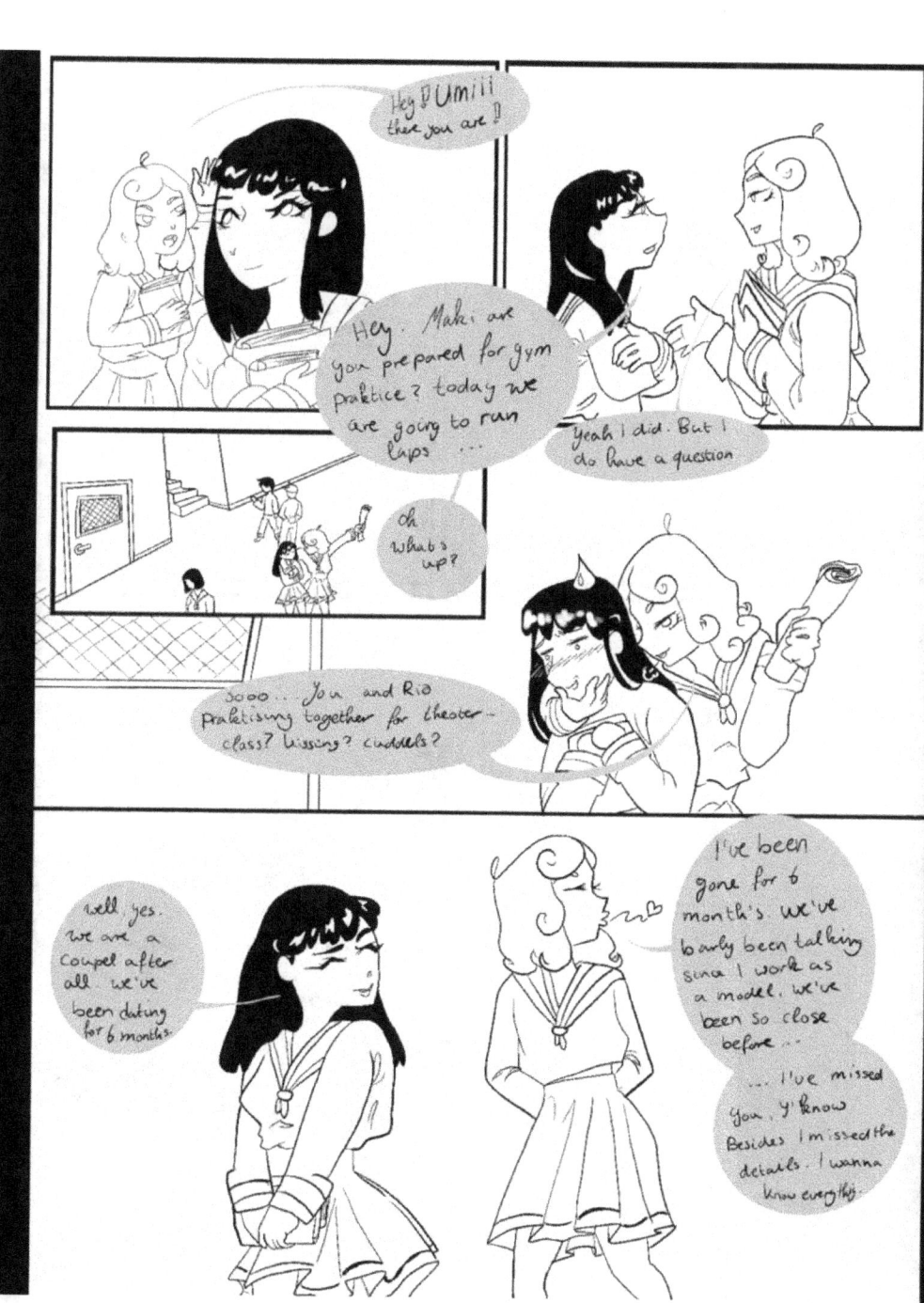

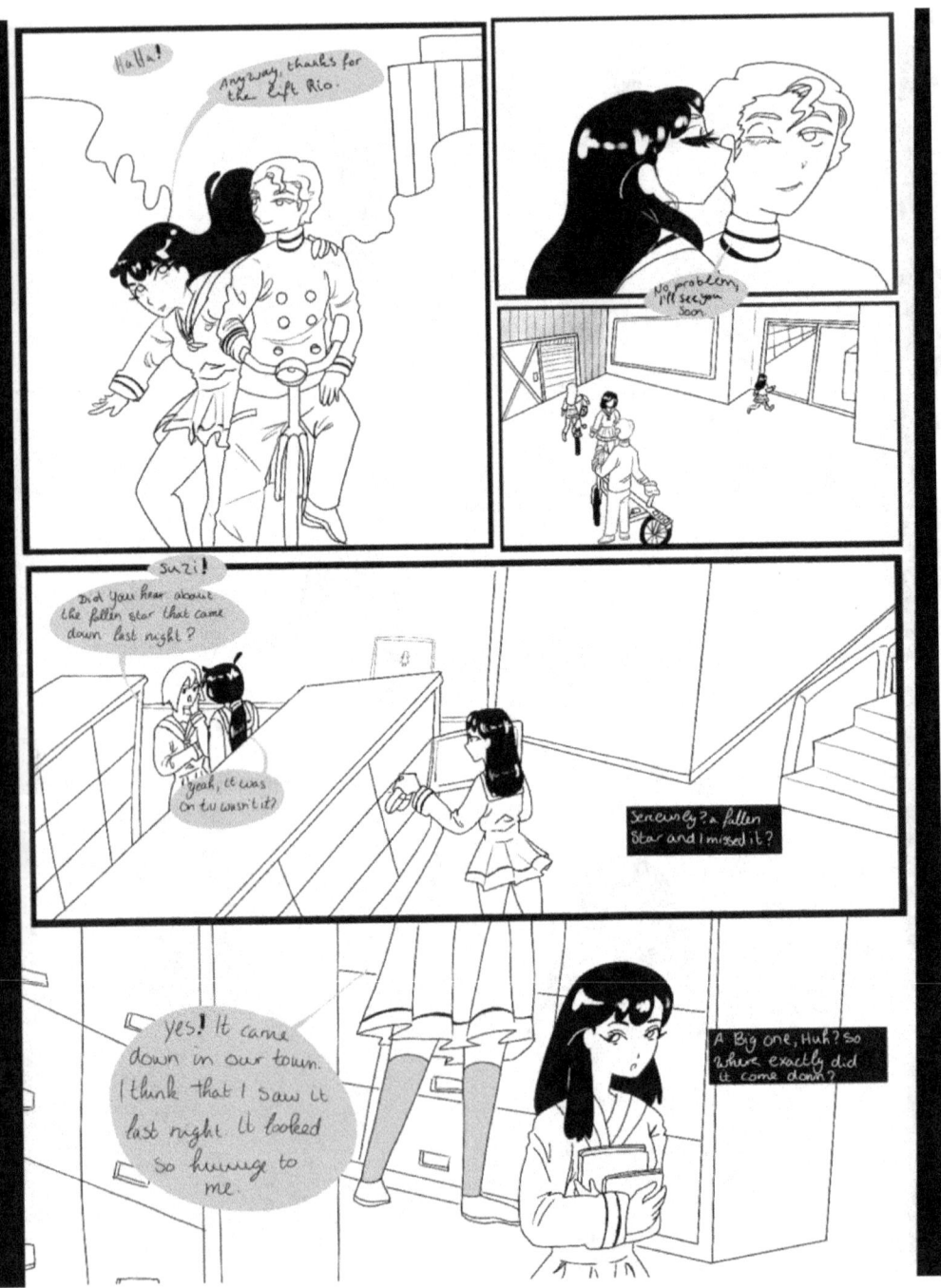

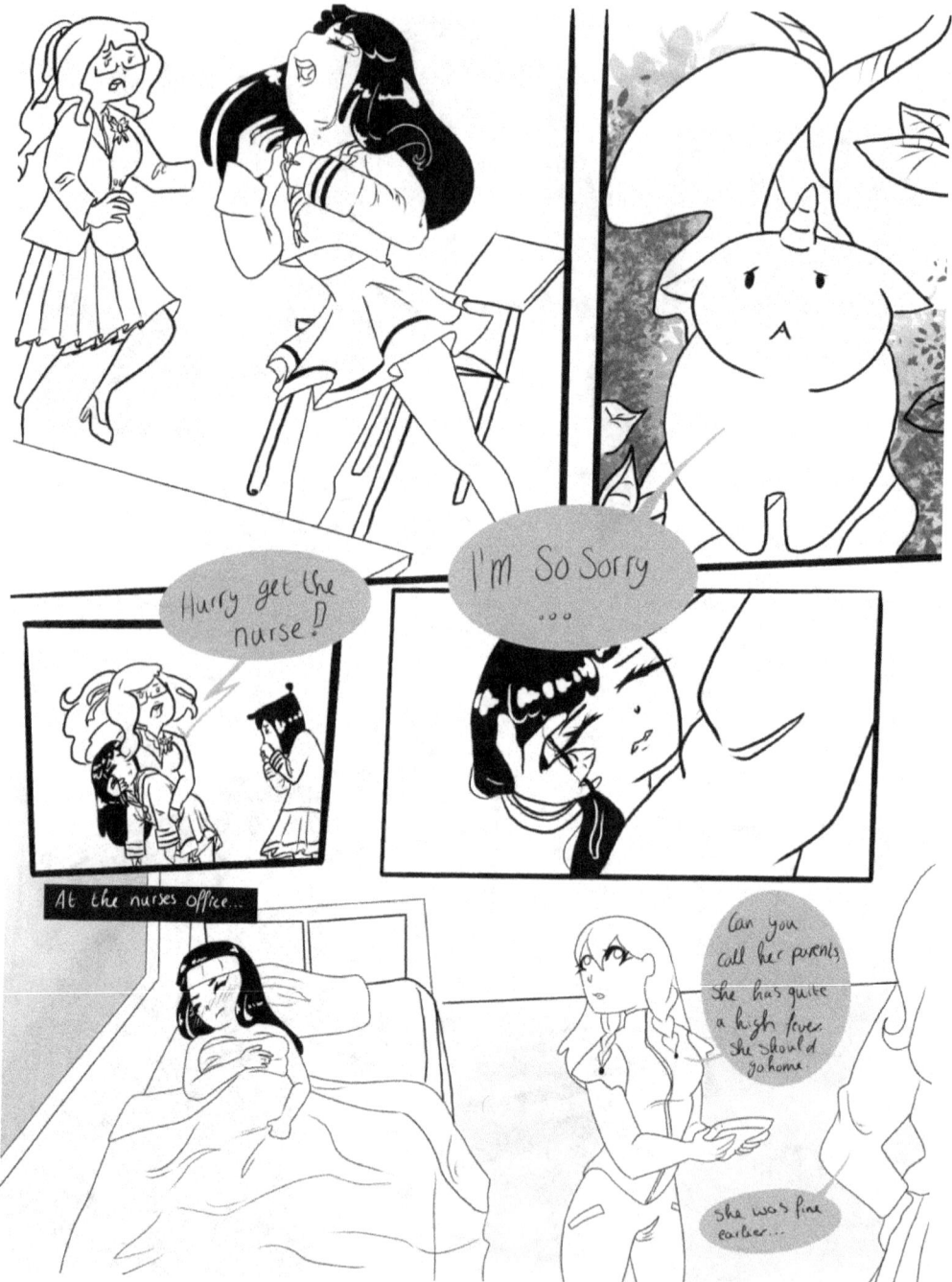

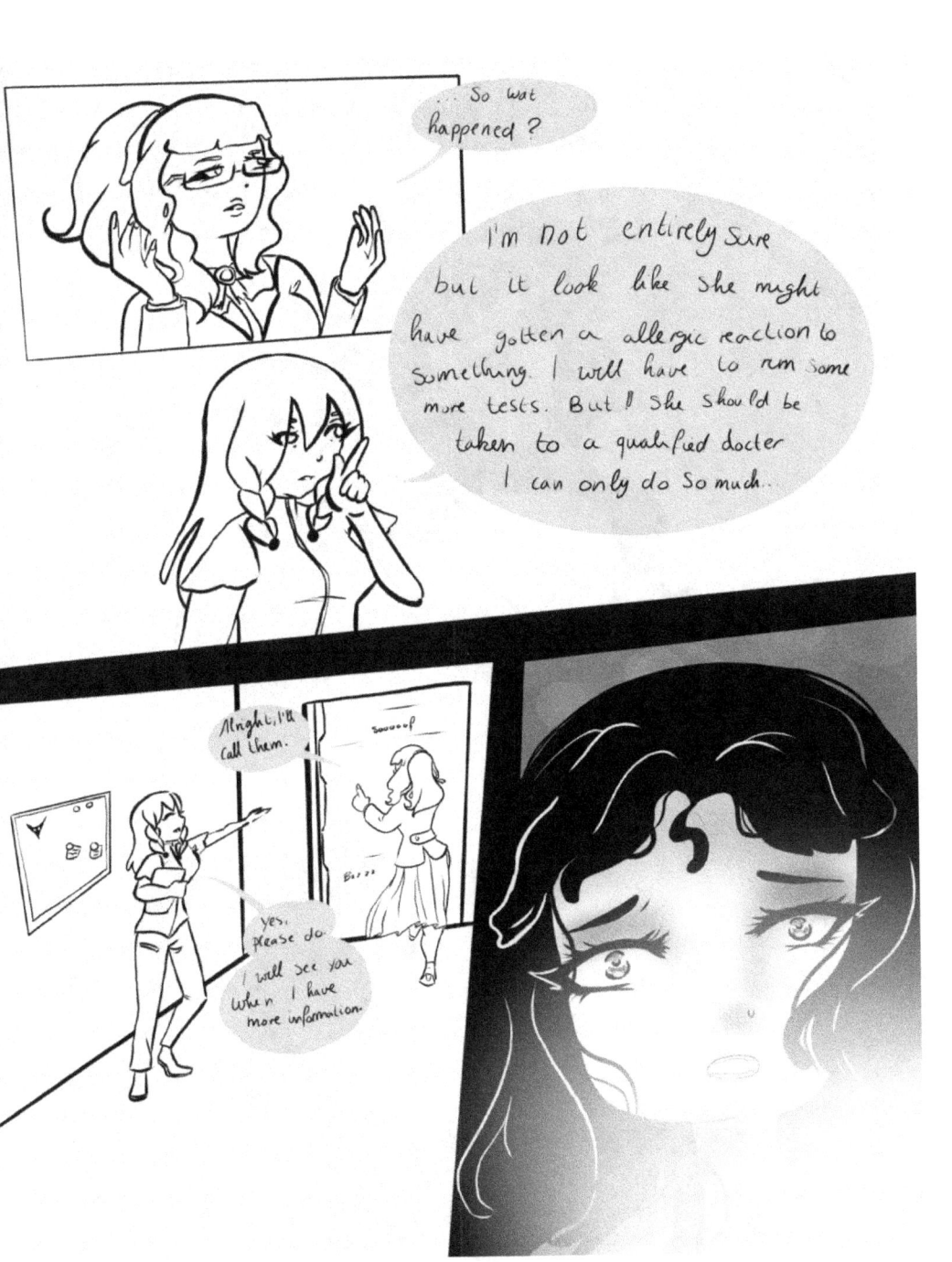

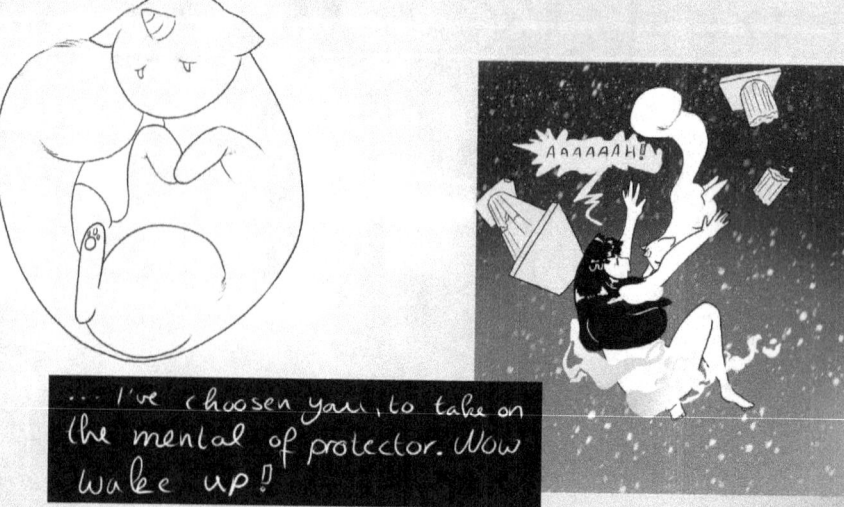

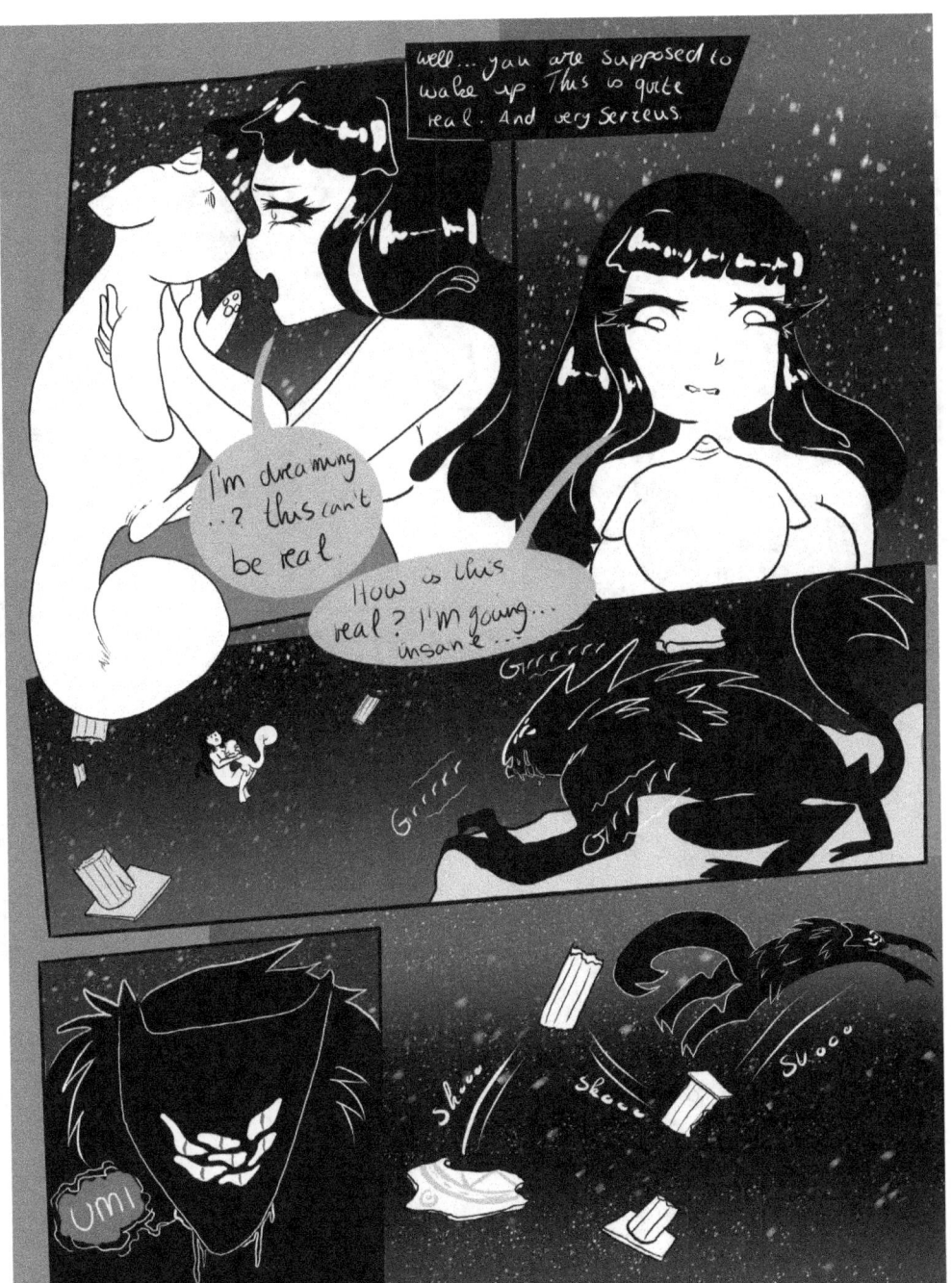

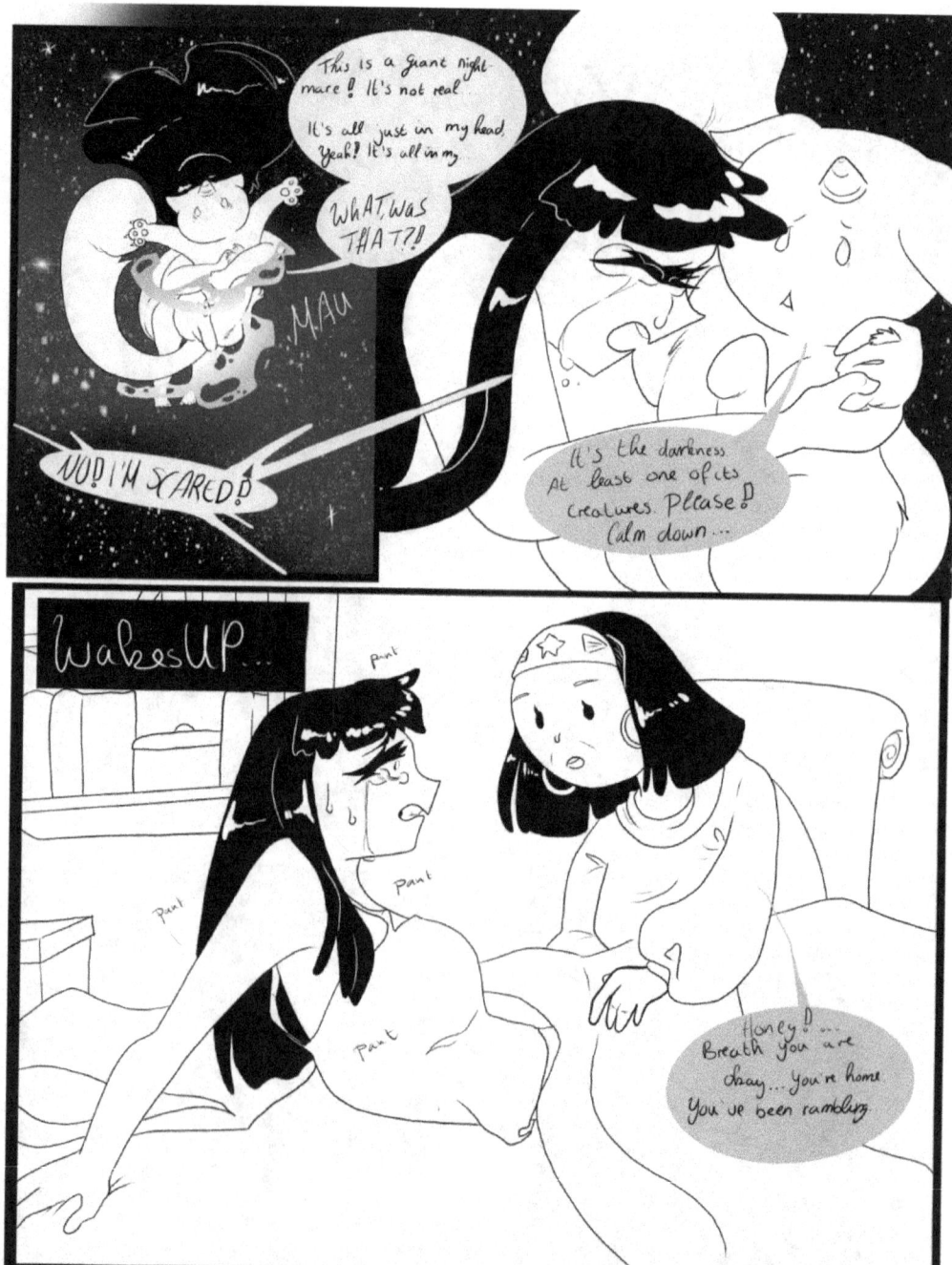

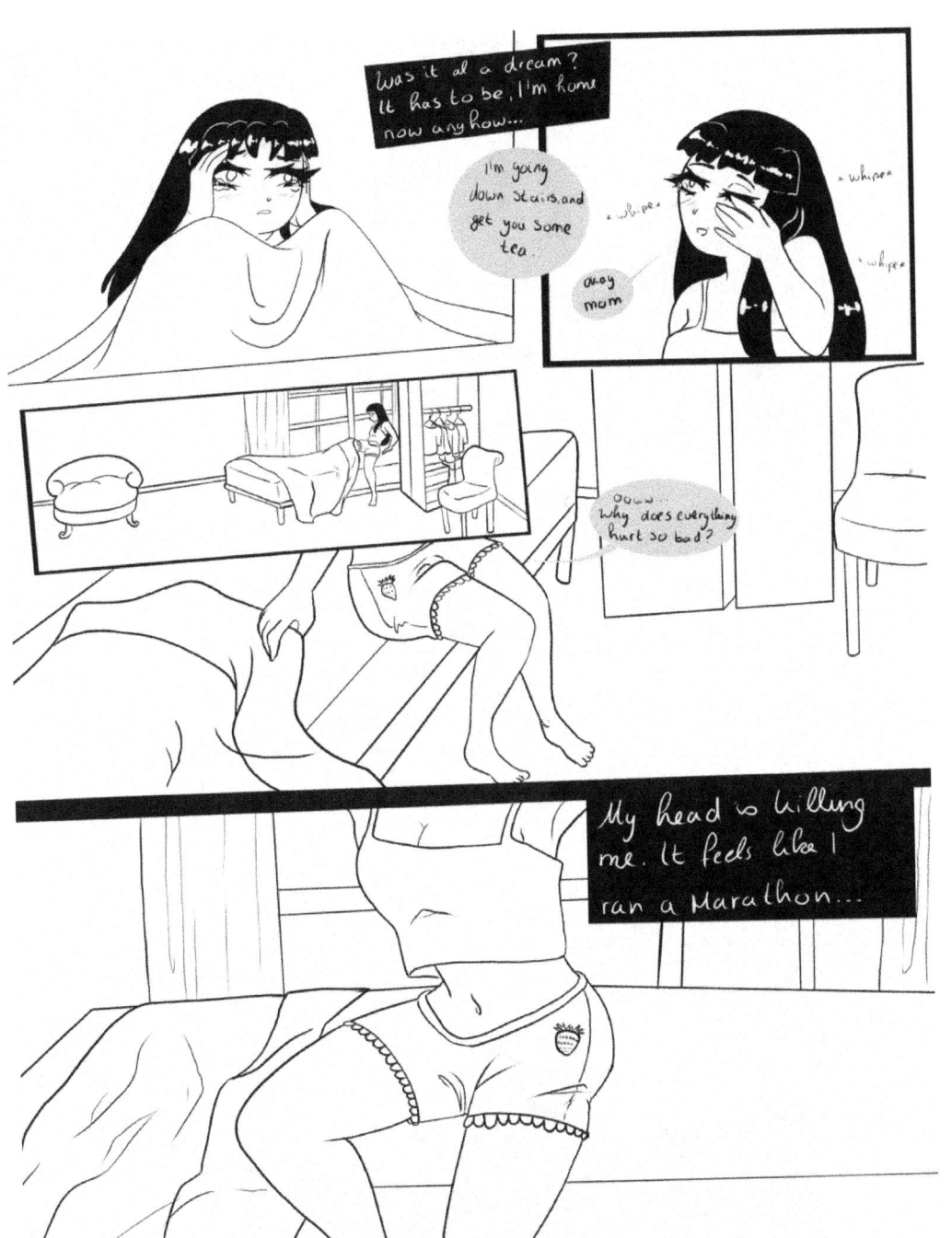

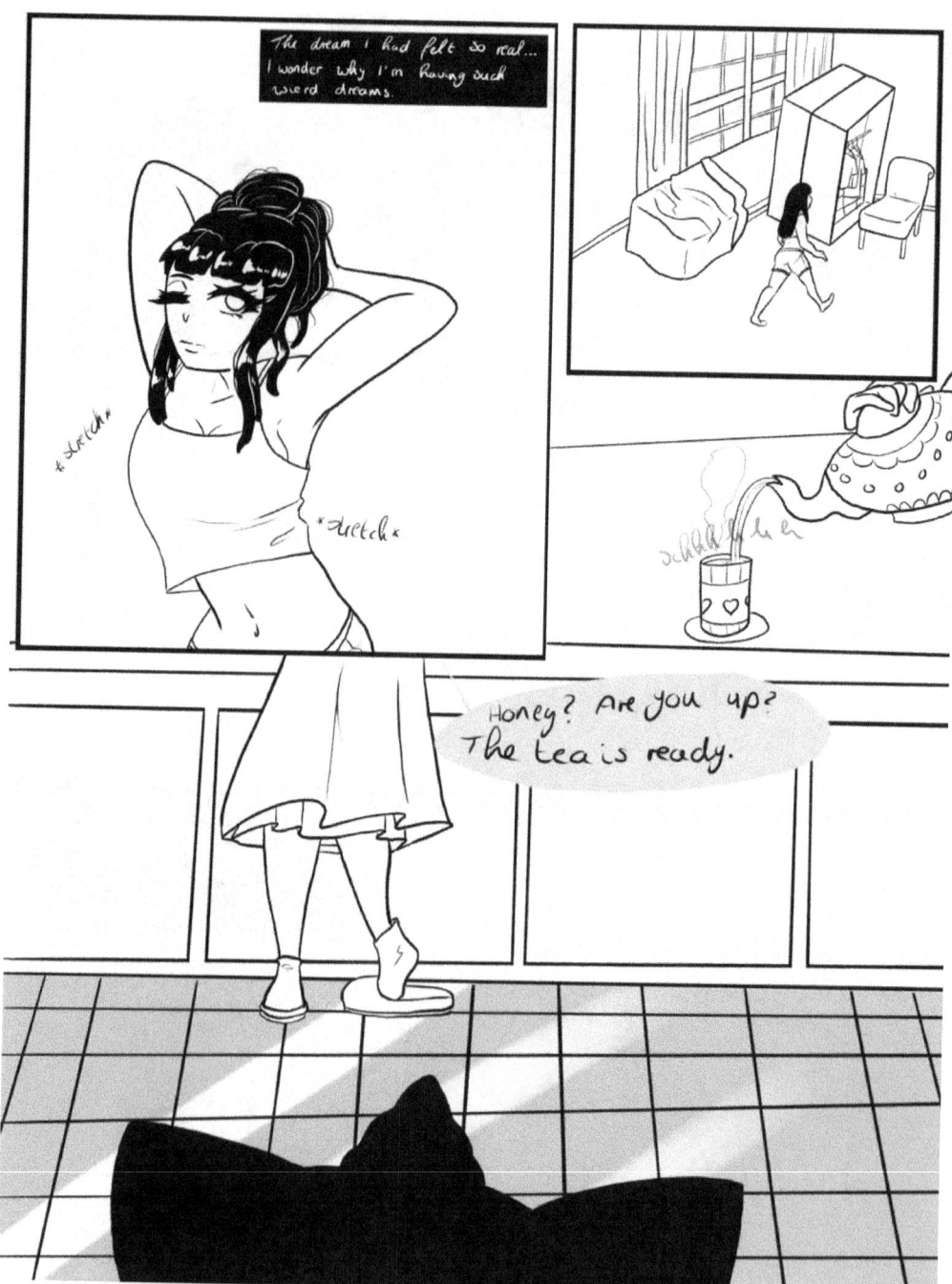

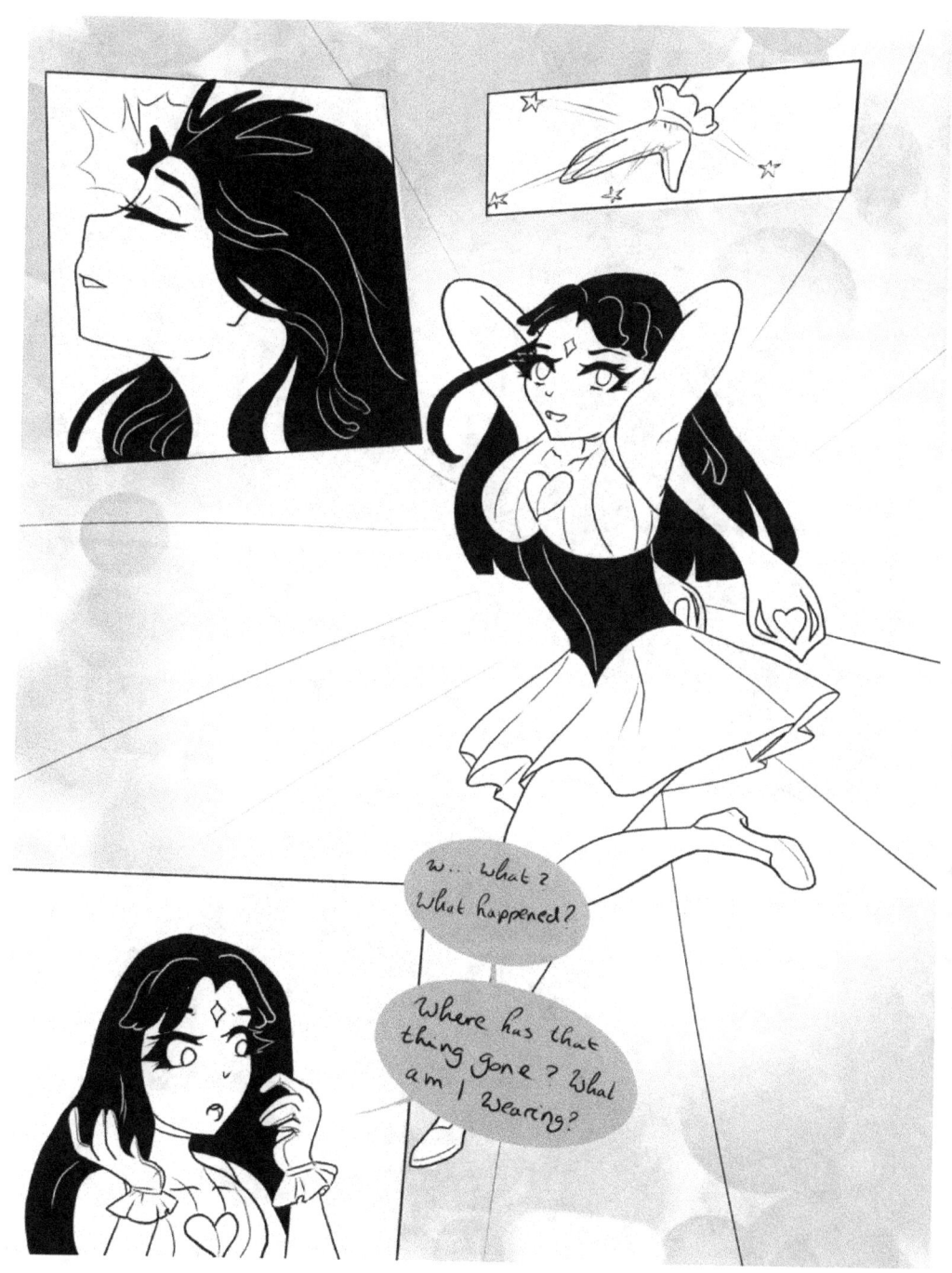

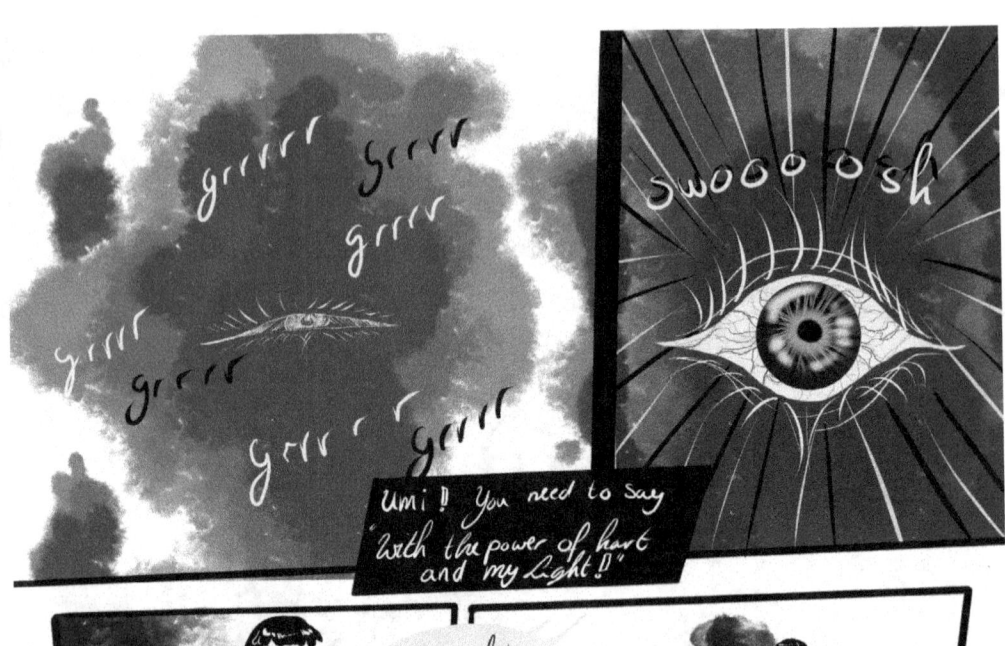
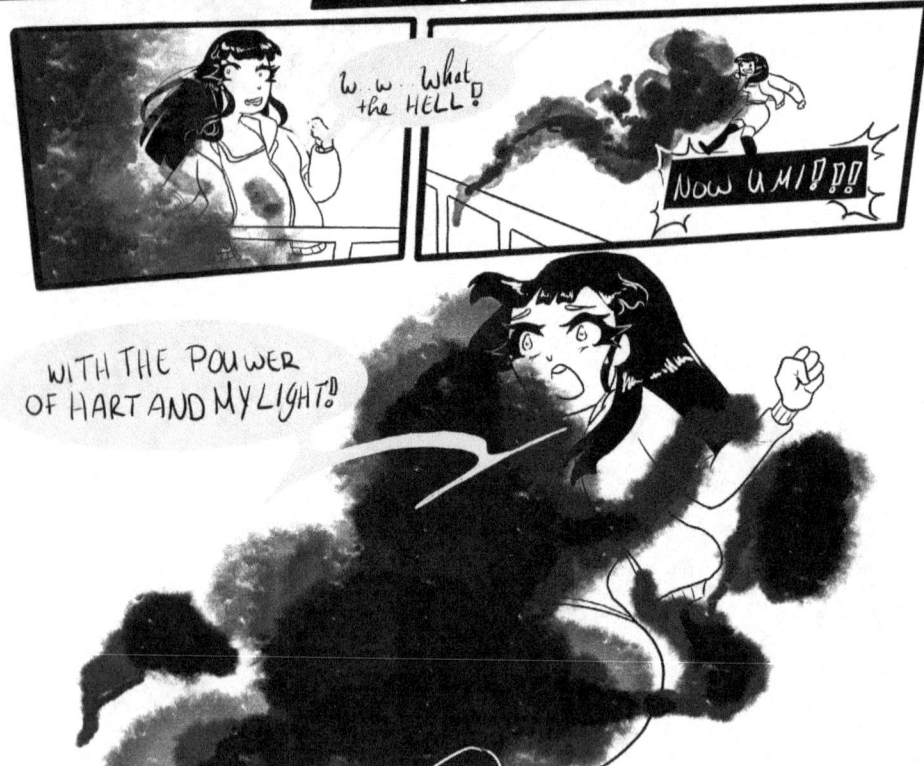

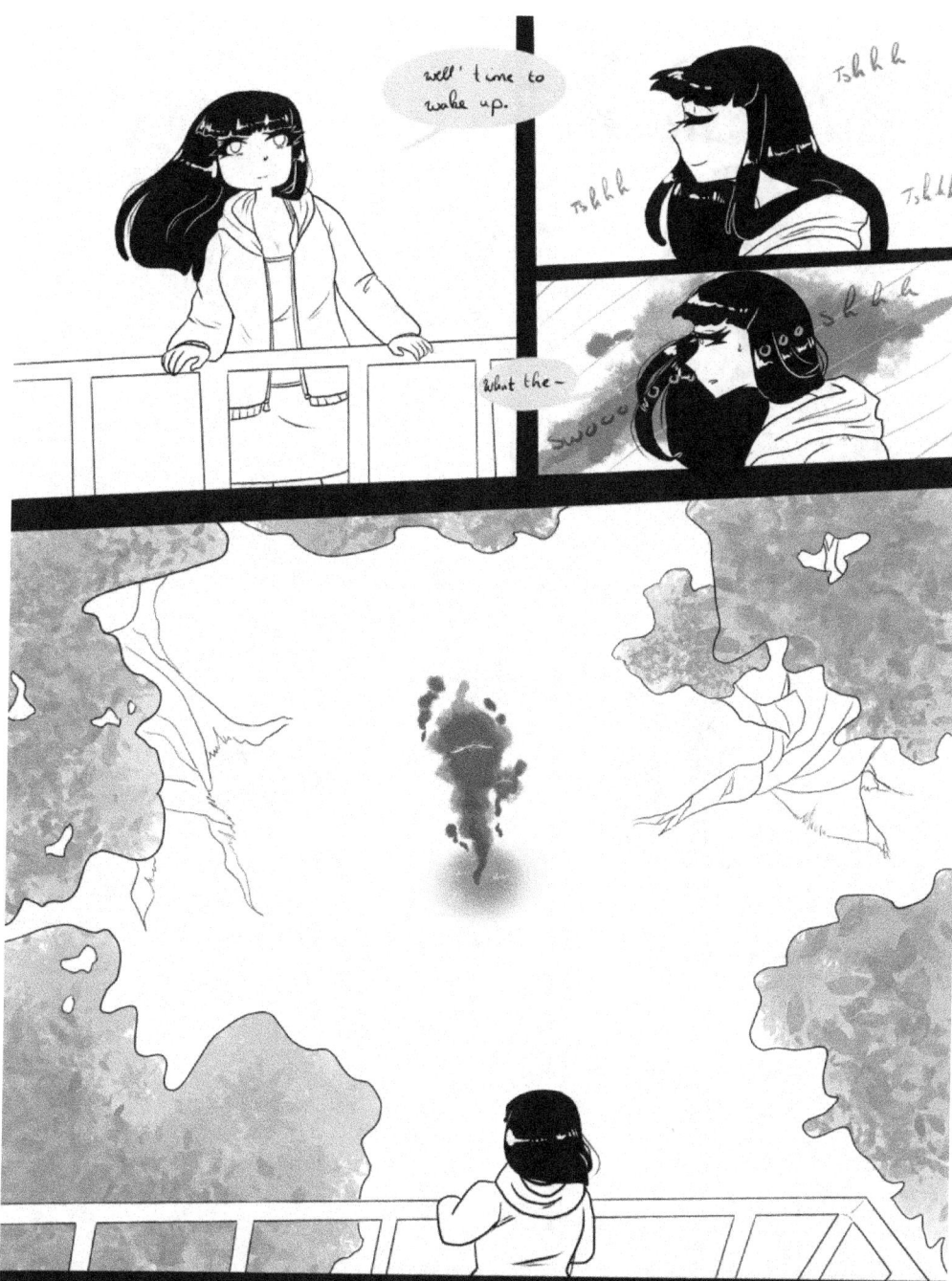

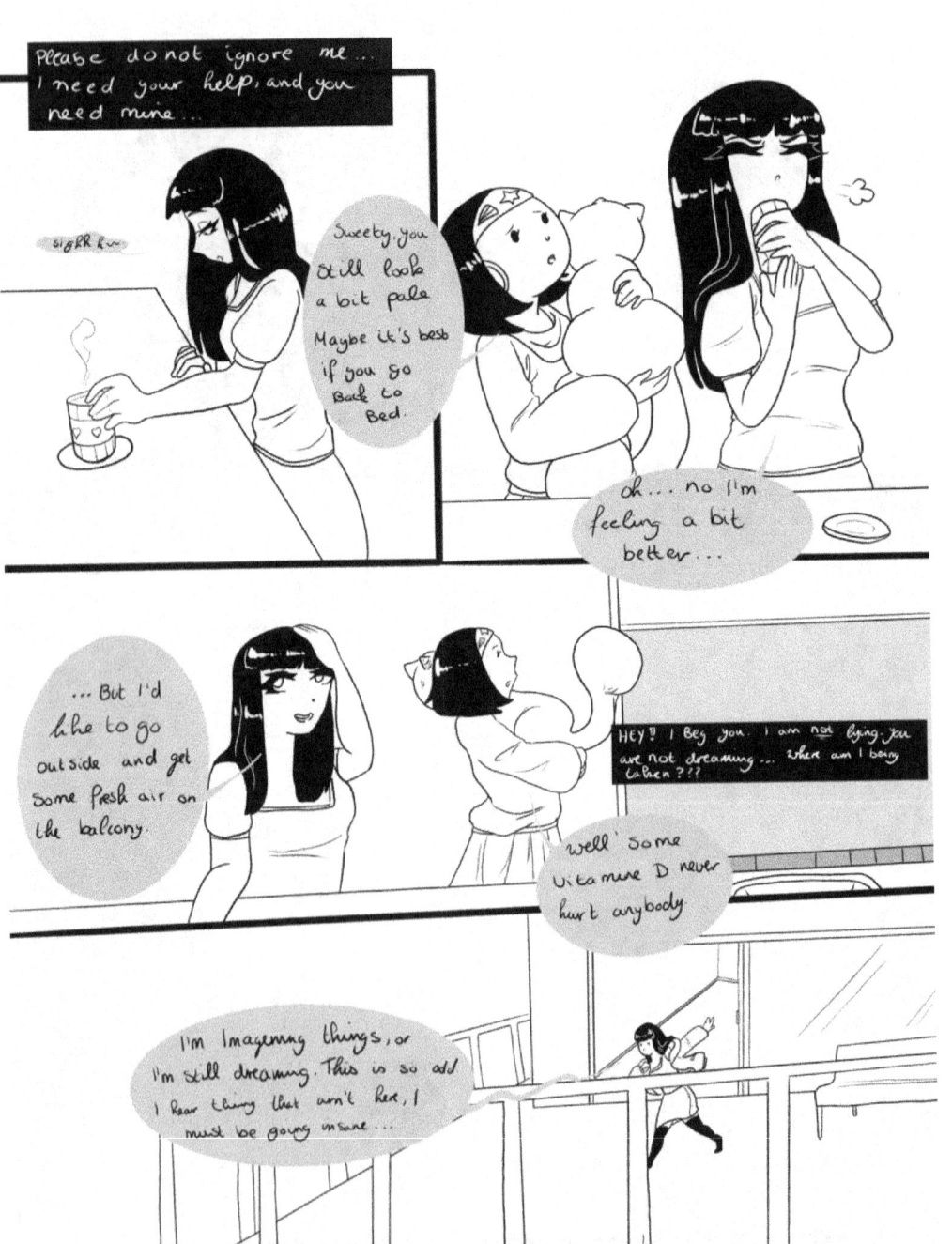

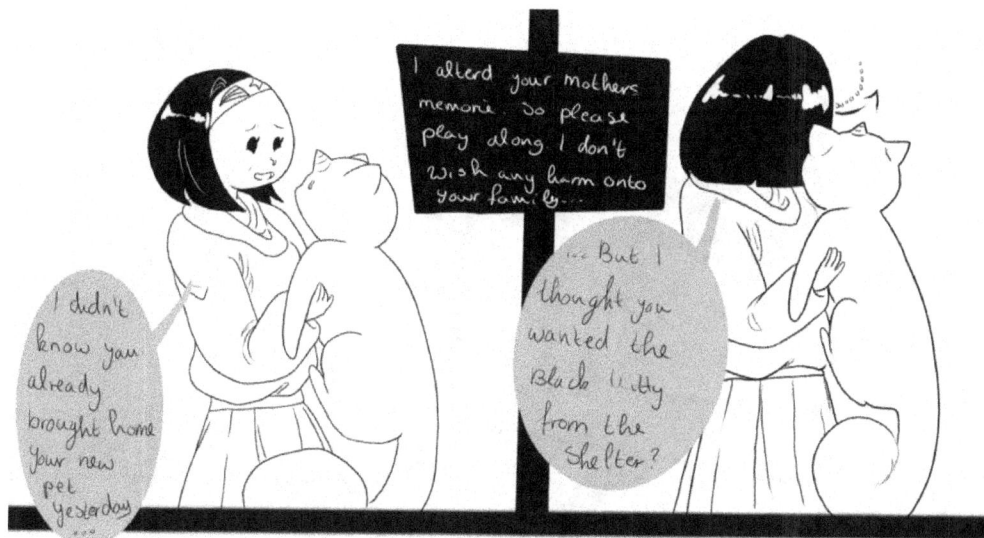

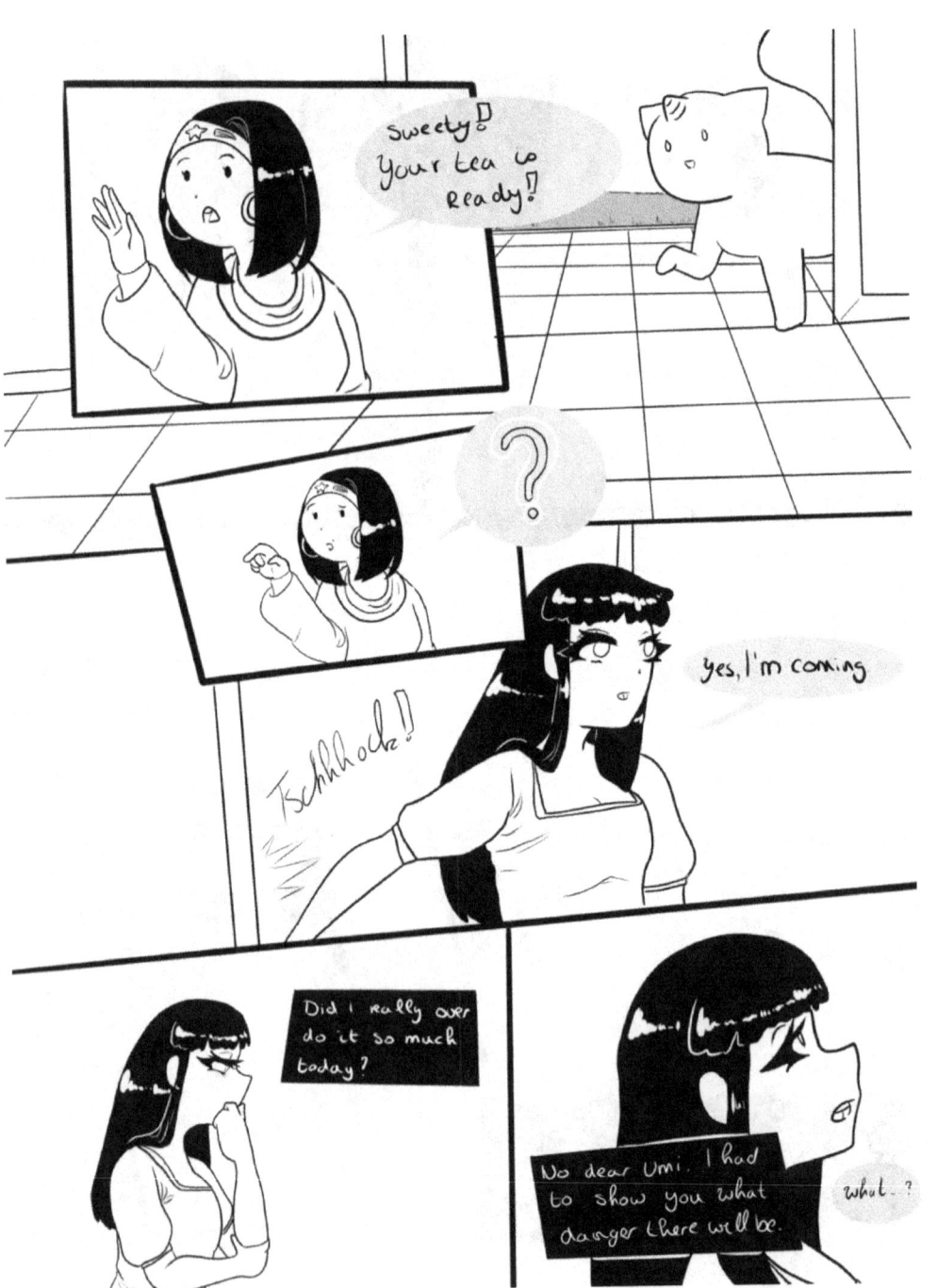

CHAPTER TWO

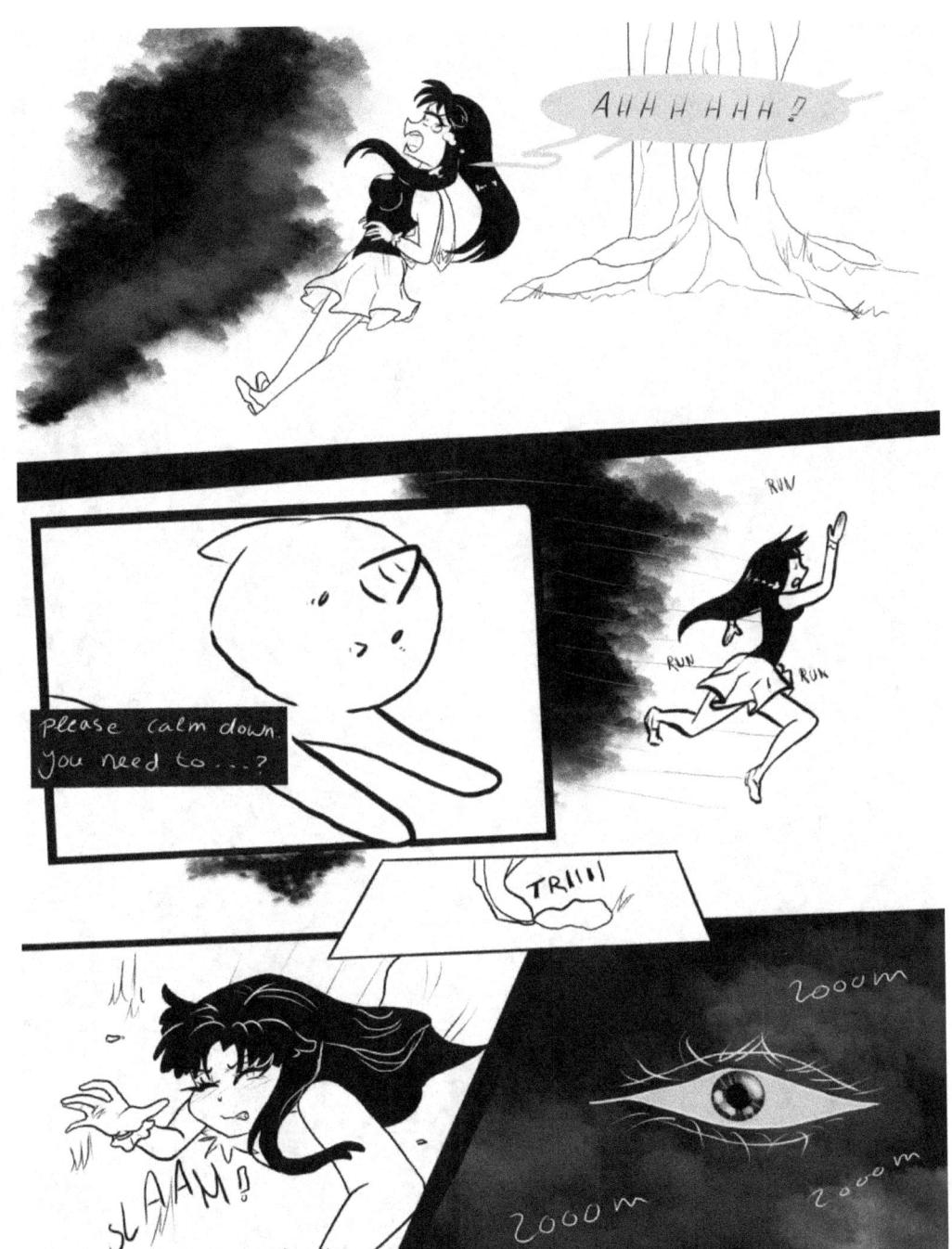

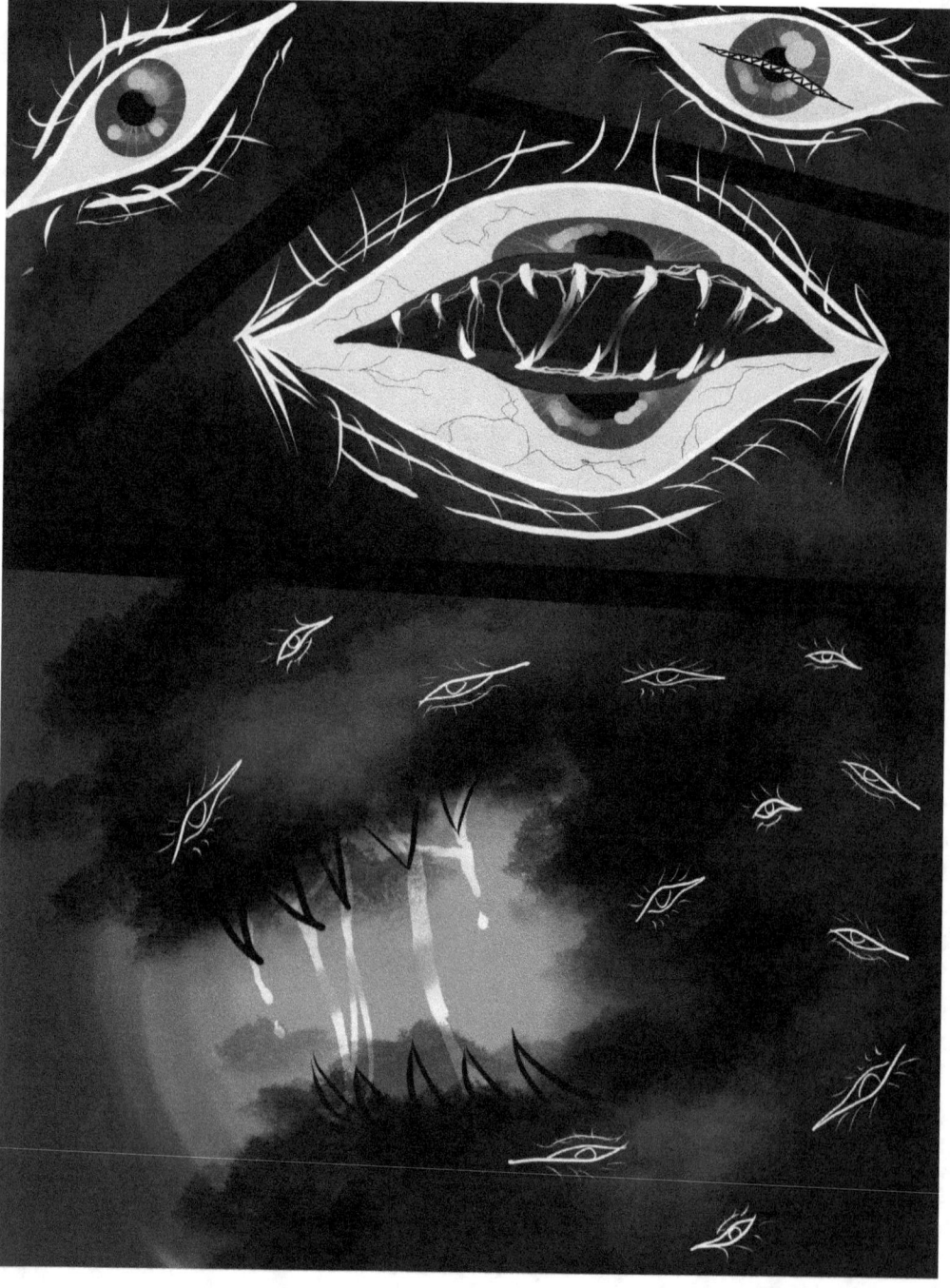

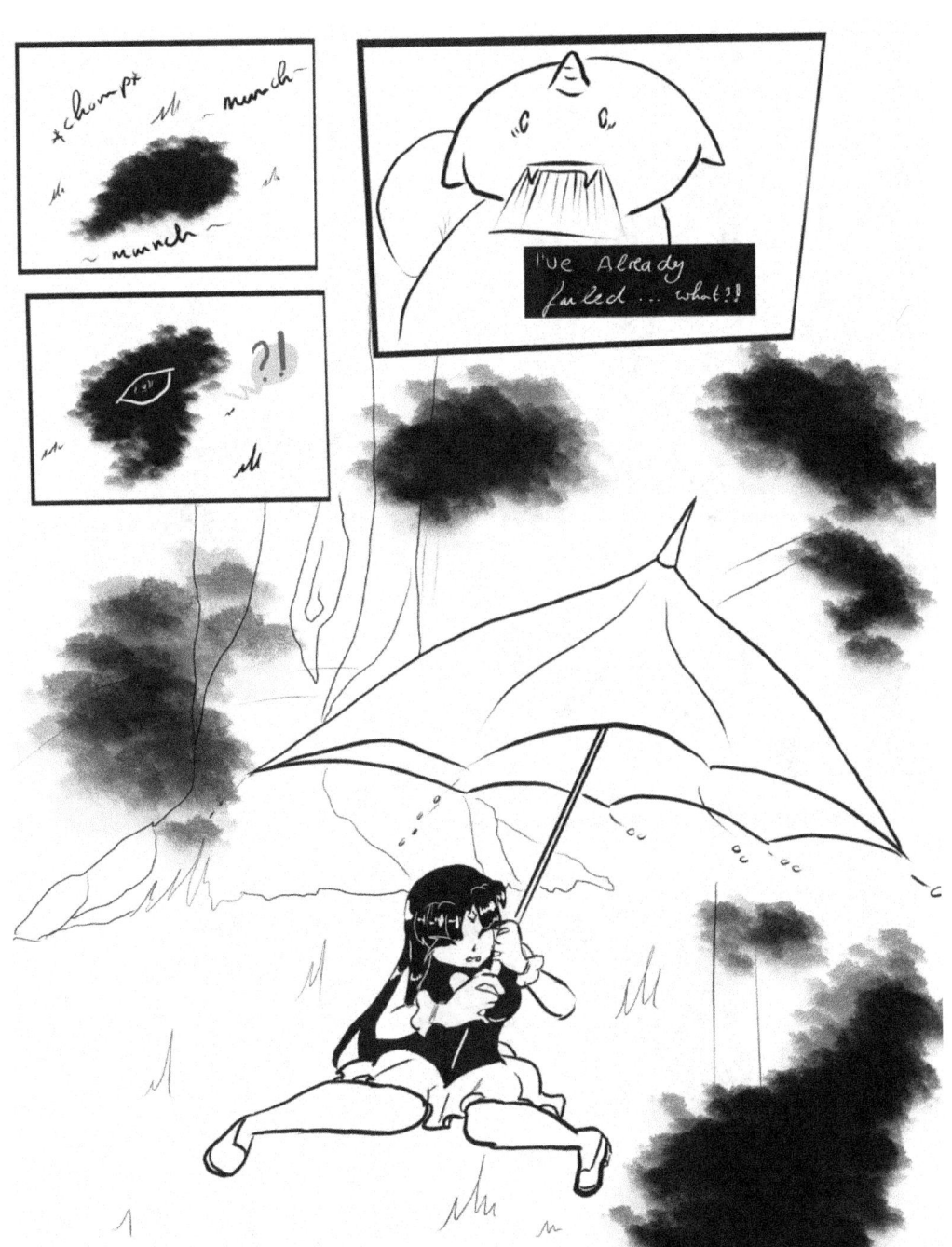

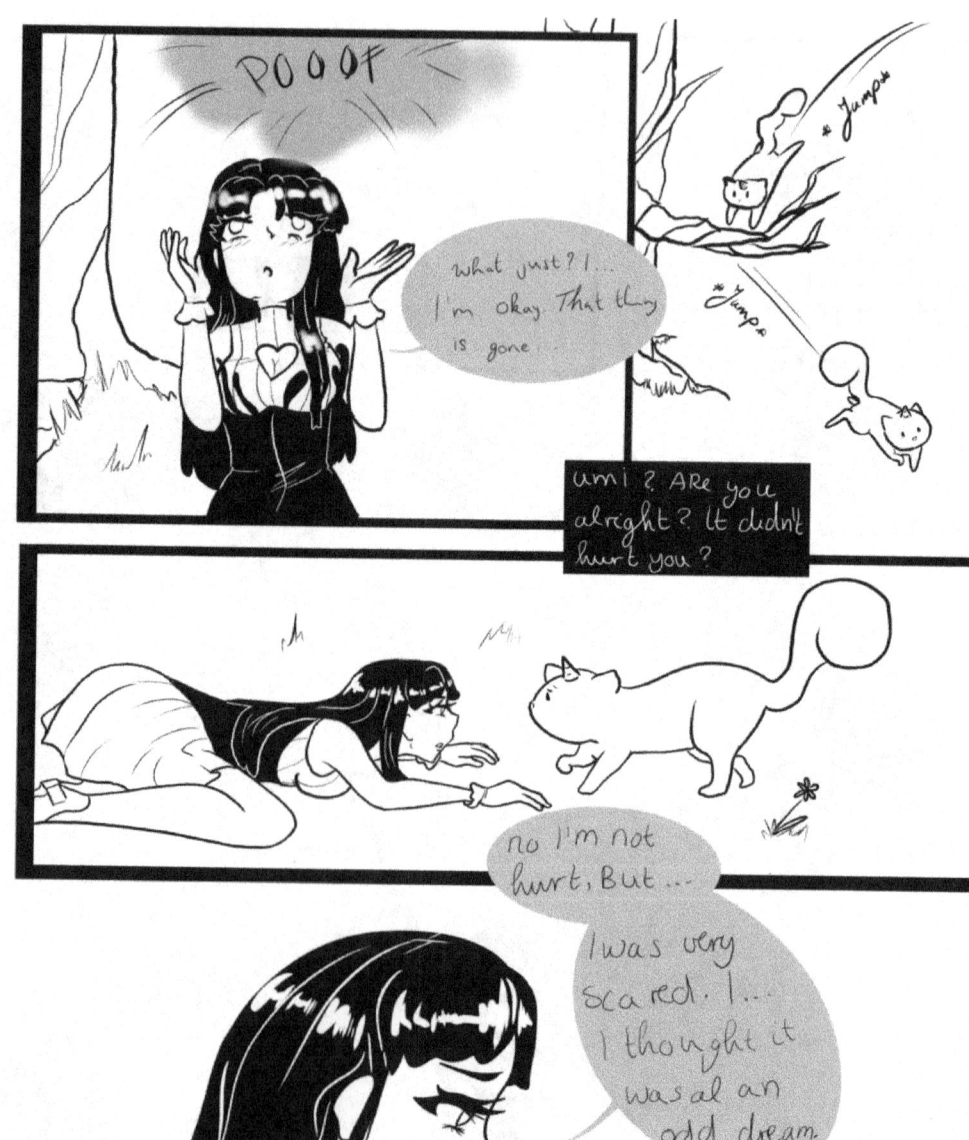

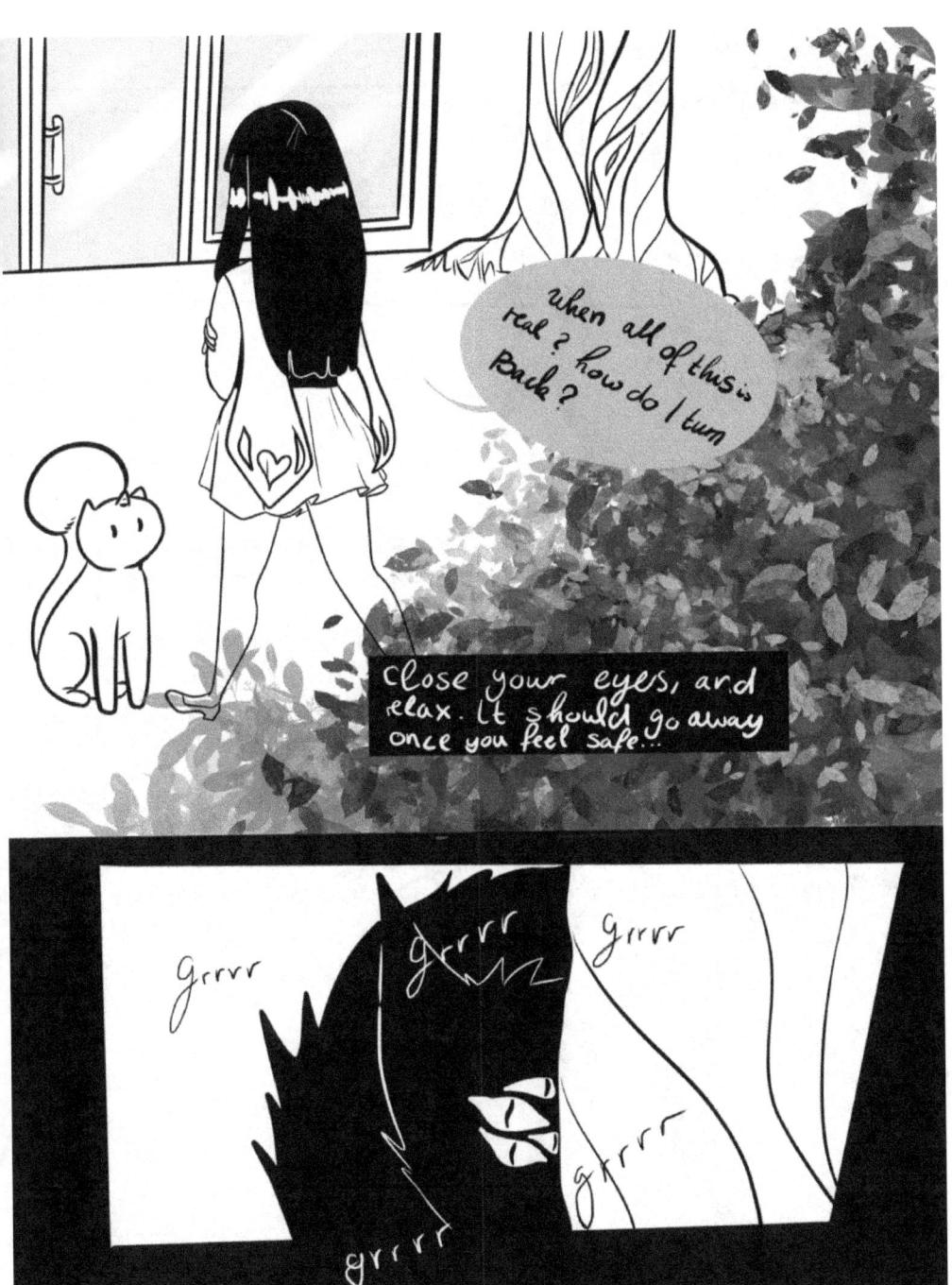

THE NEXT DAY...

I barely slept last night. I'm soooo... bored.

I am certain you will be fine today. I will be seeing you in a bit...

...I'm afraid that I have to check something. I hope that my fear is... unreasoned.

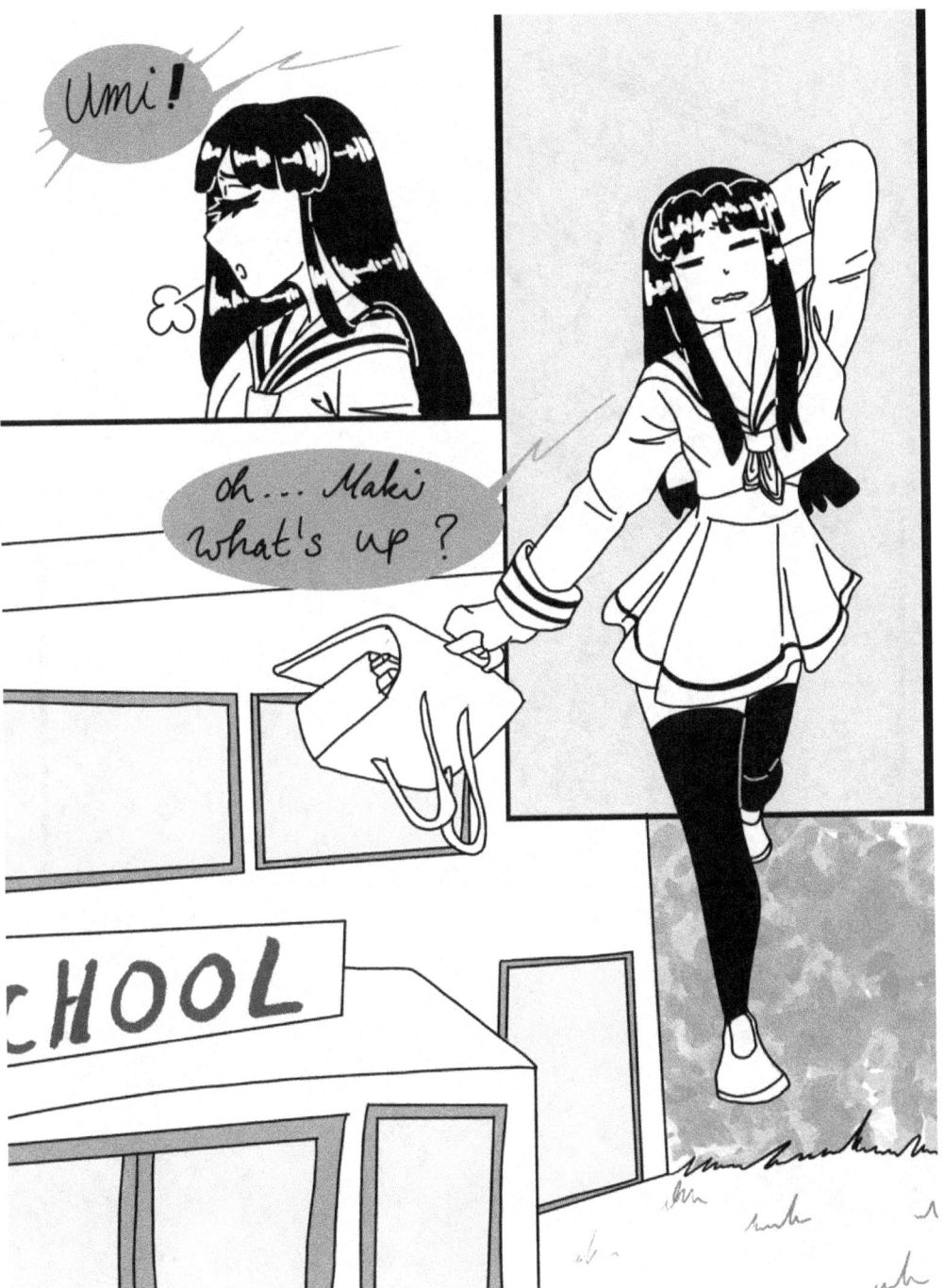

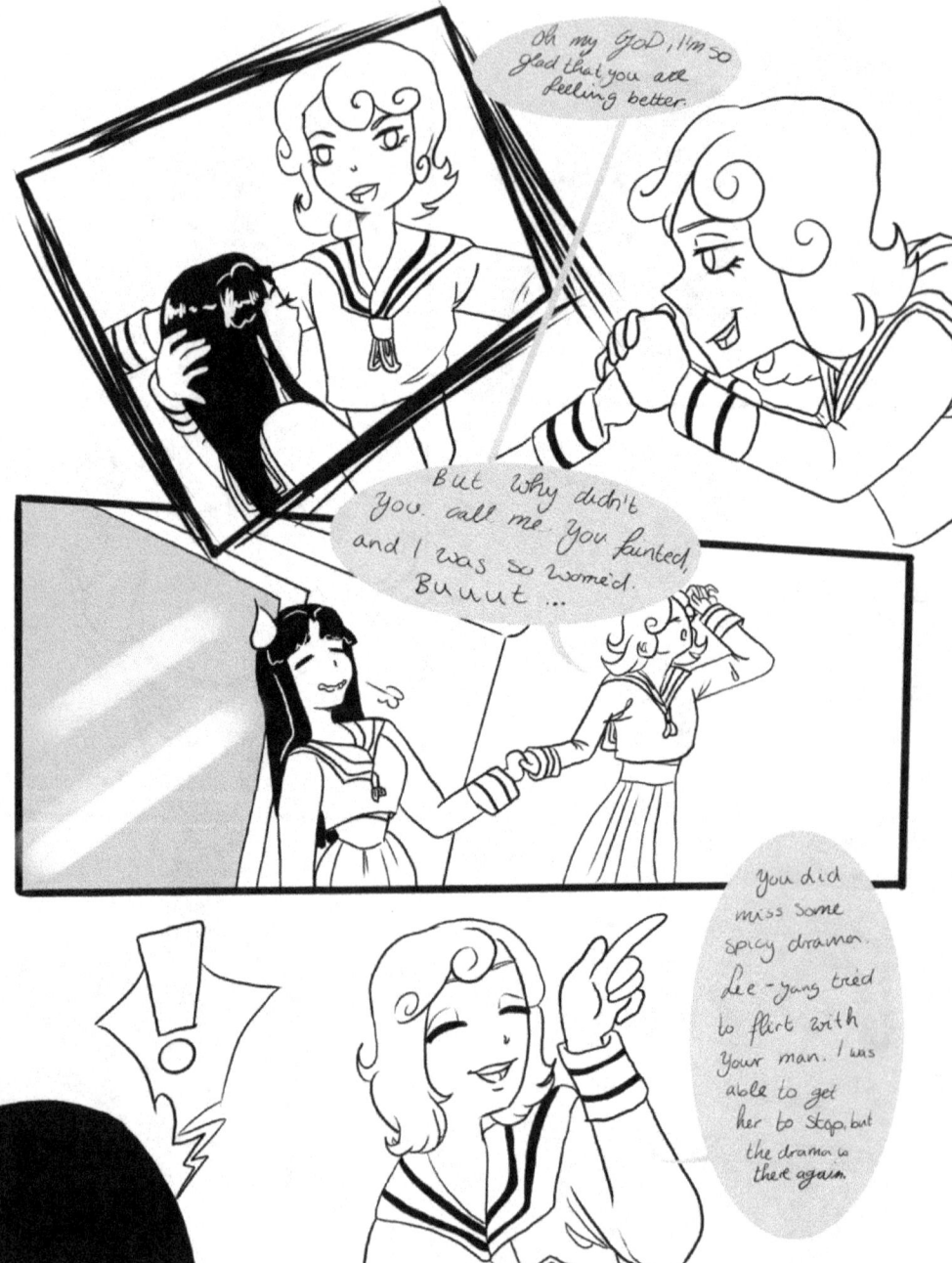

Oh don't worry you will figure it out soon enough!

ooo ooo owh...

in the mean time...

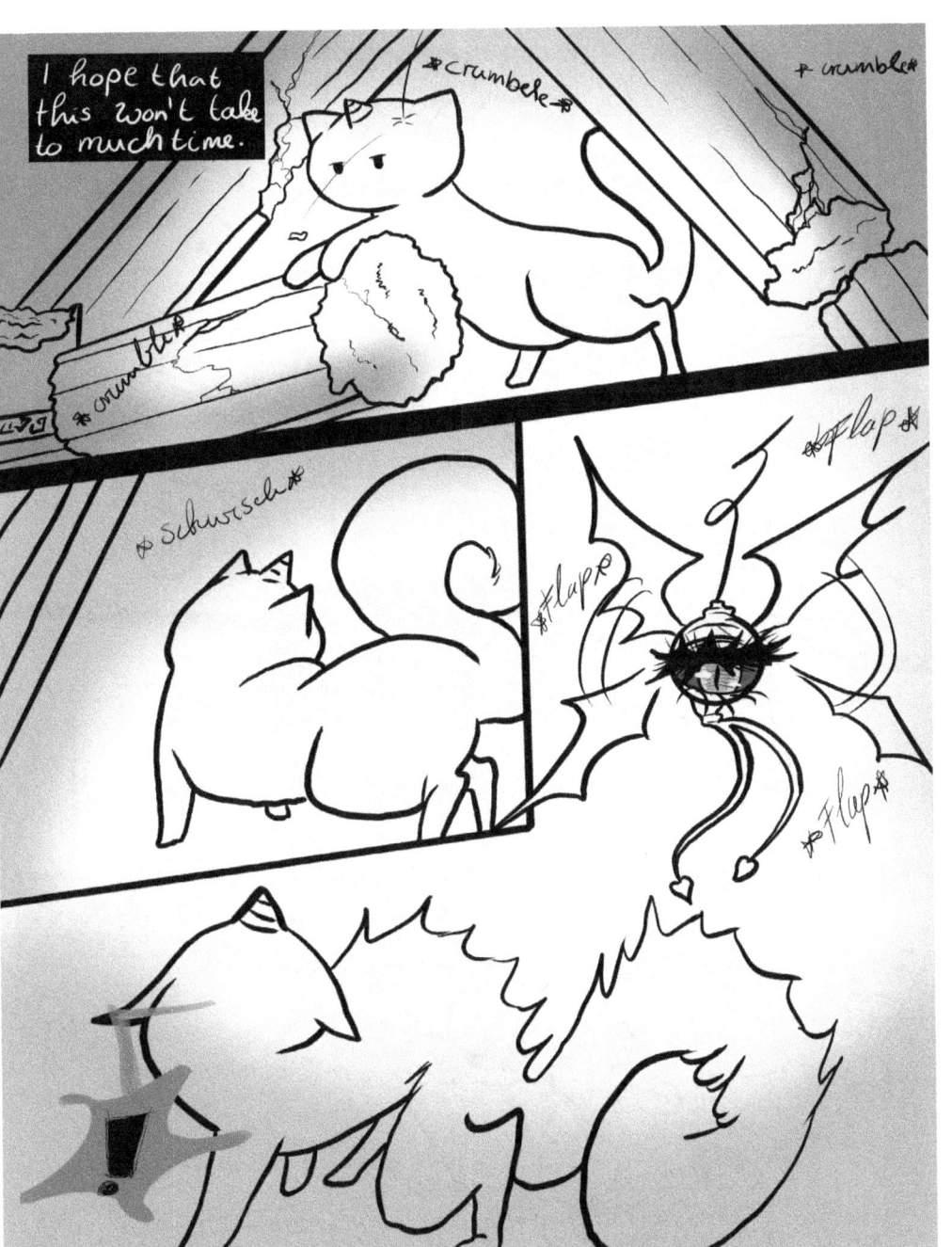

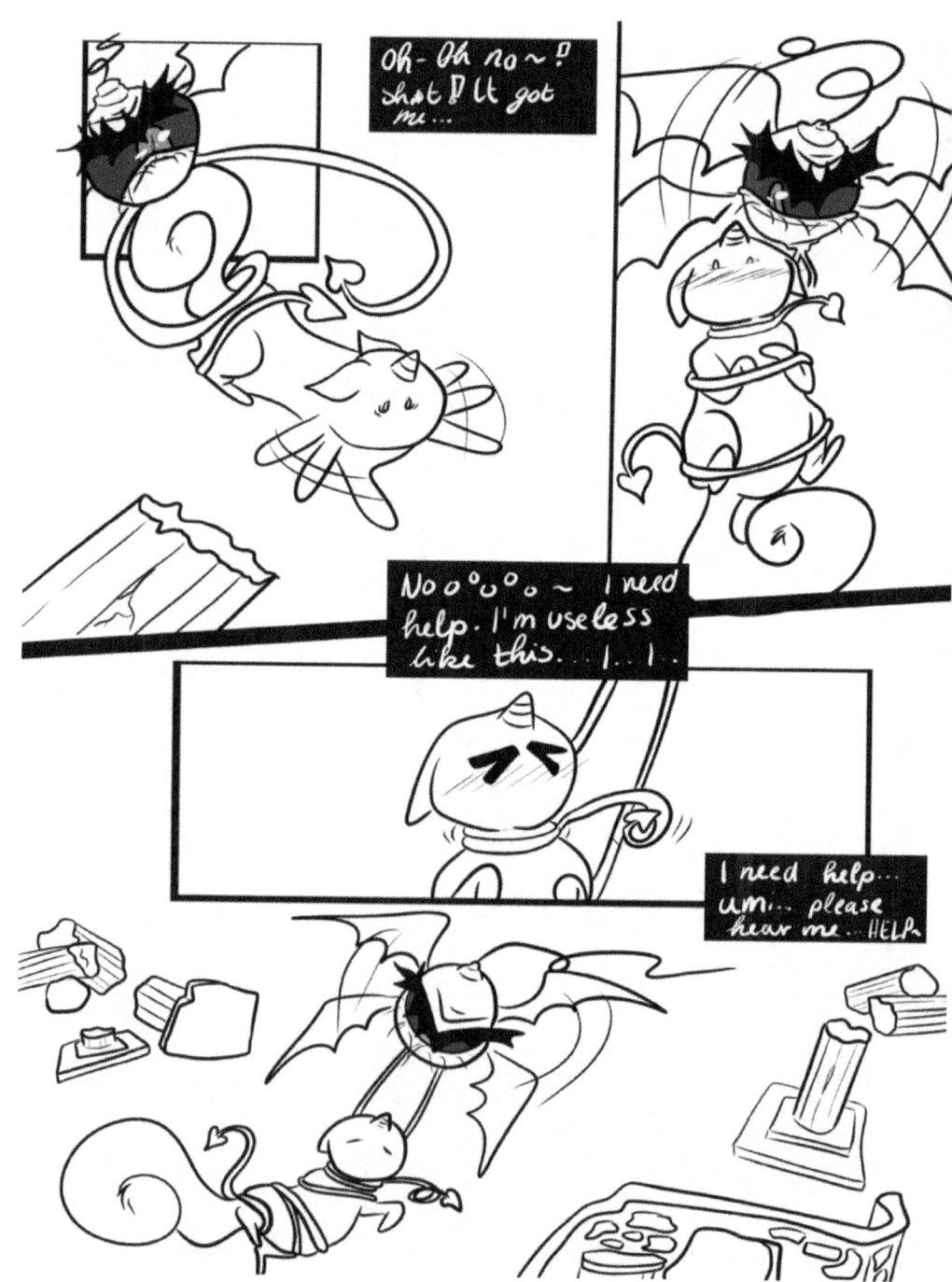

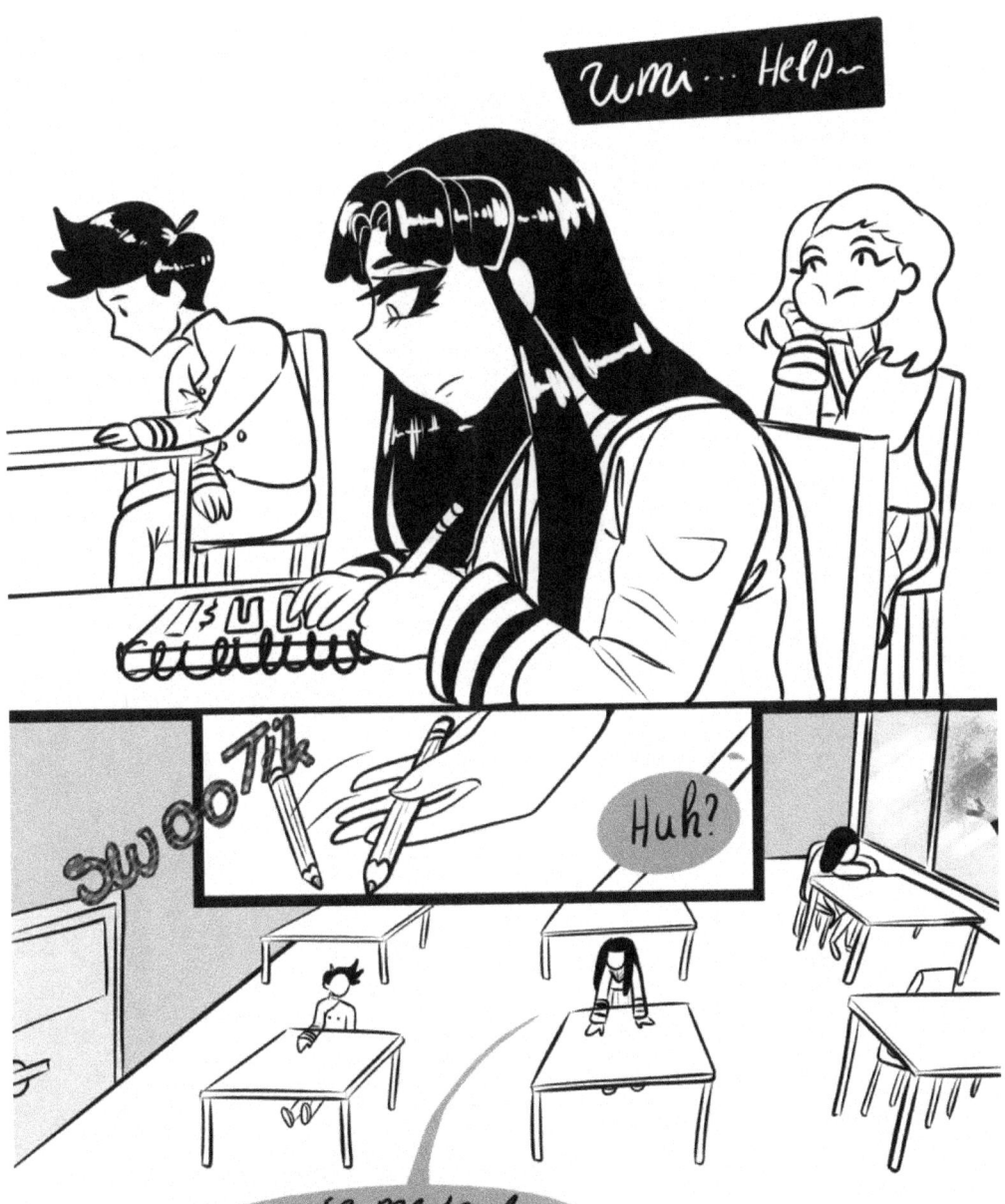

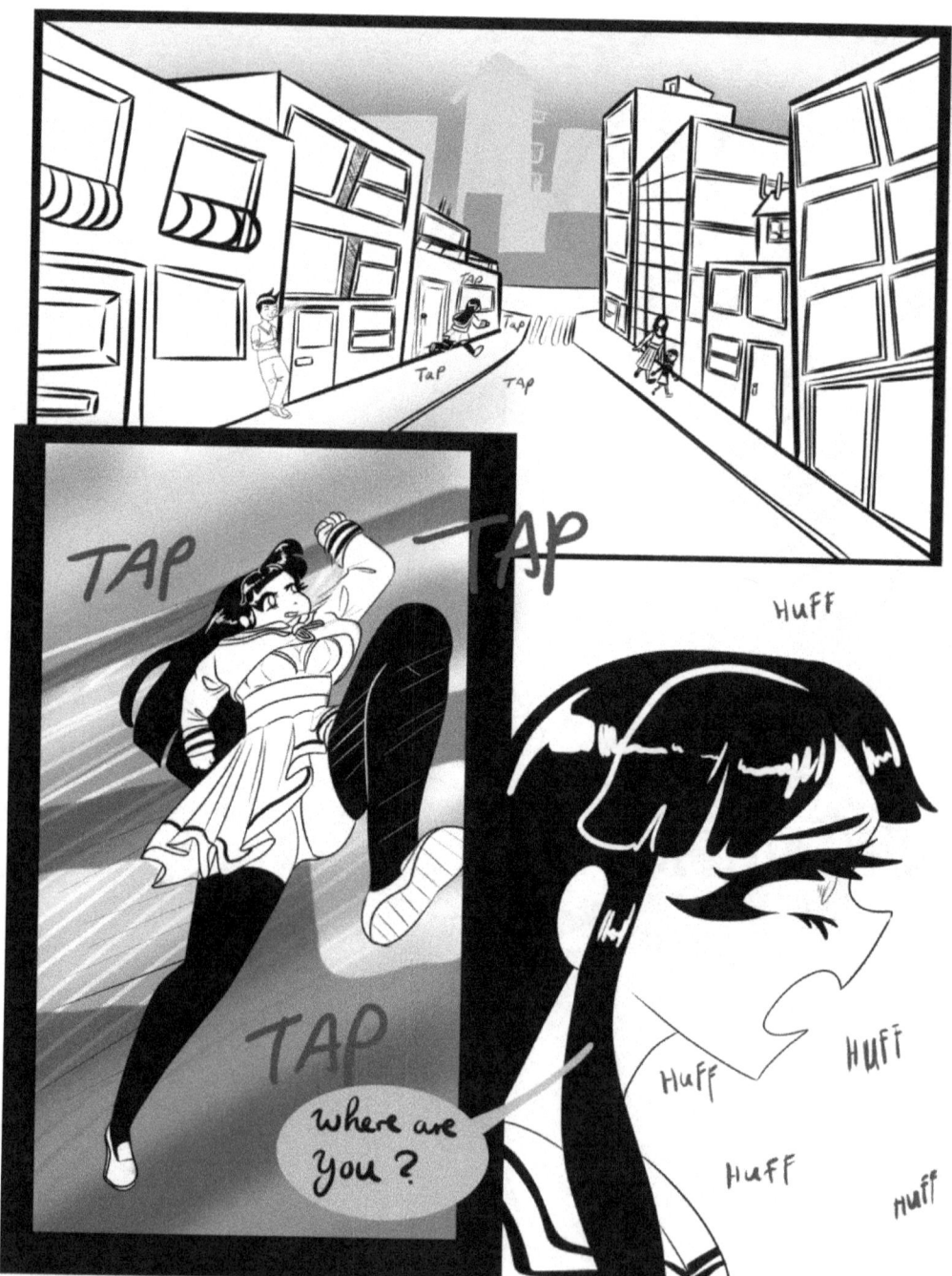

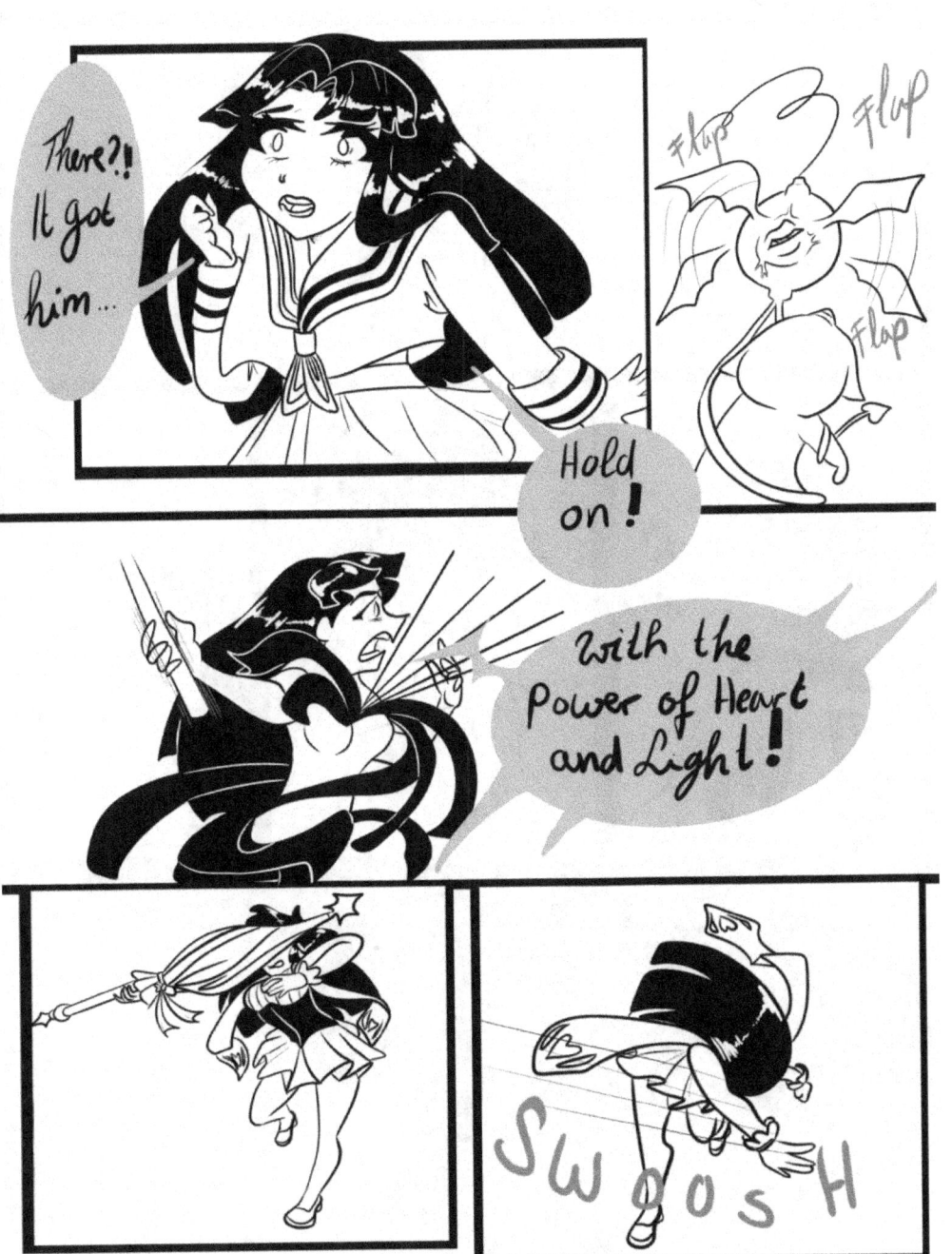

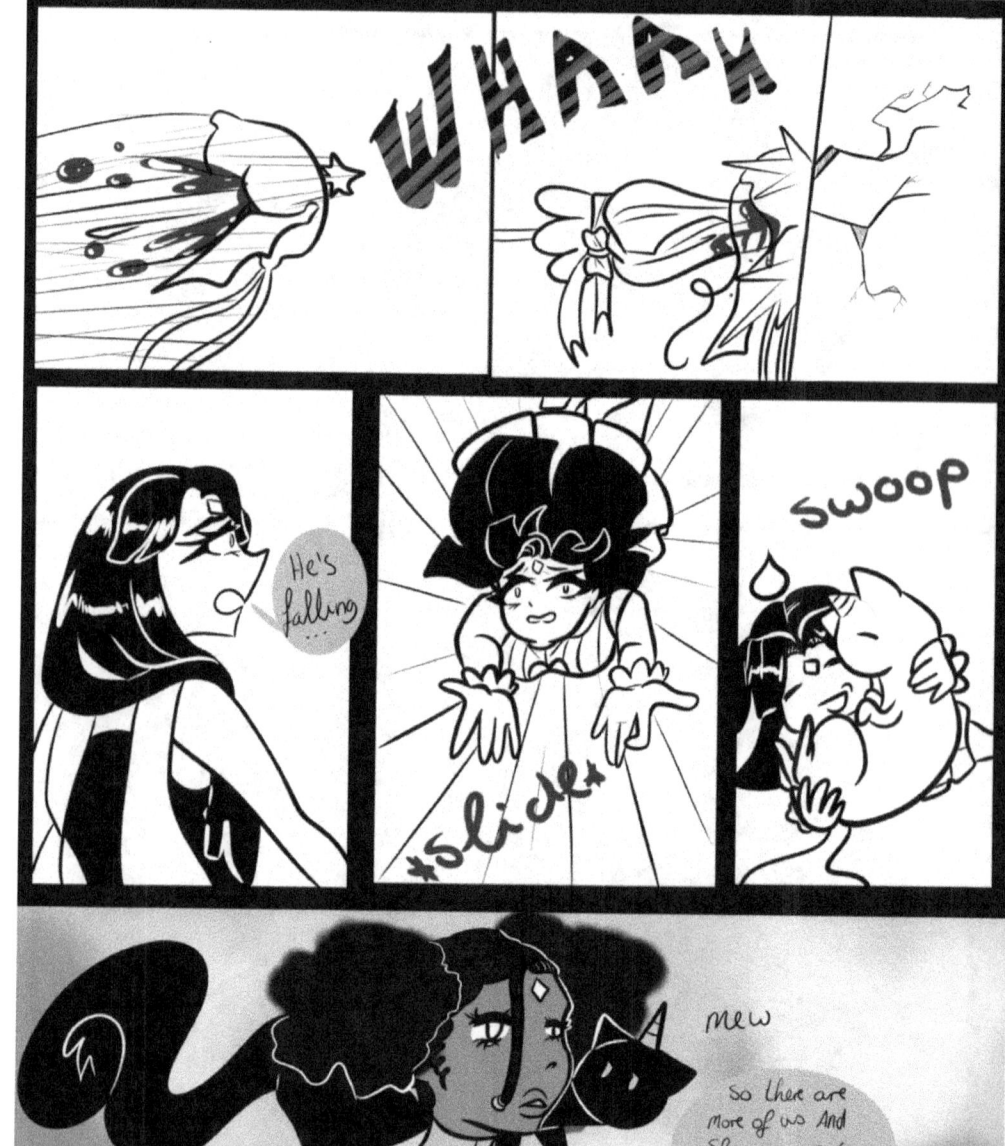

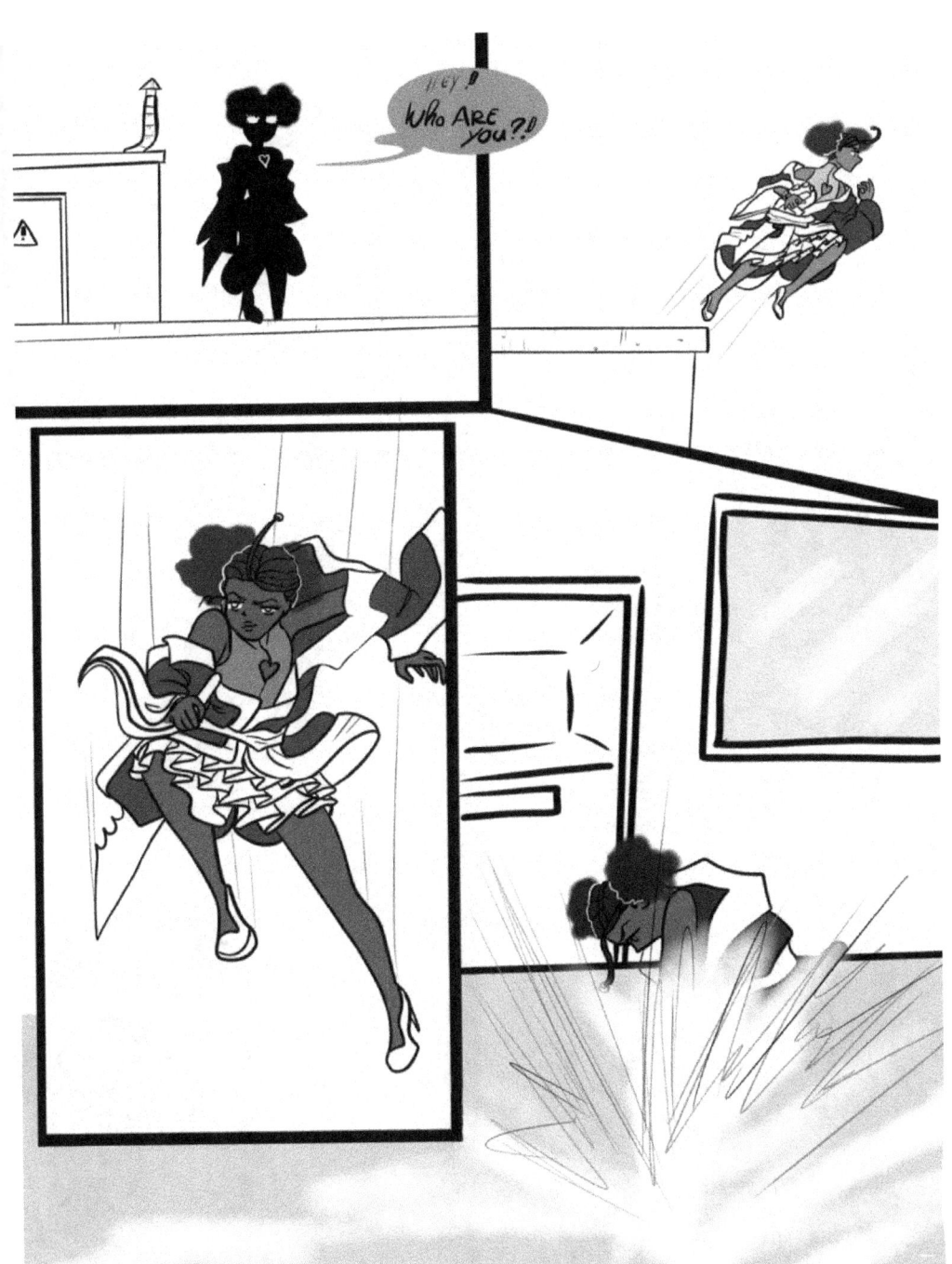

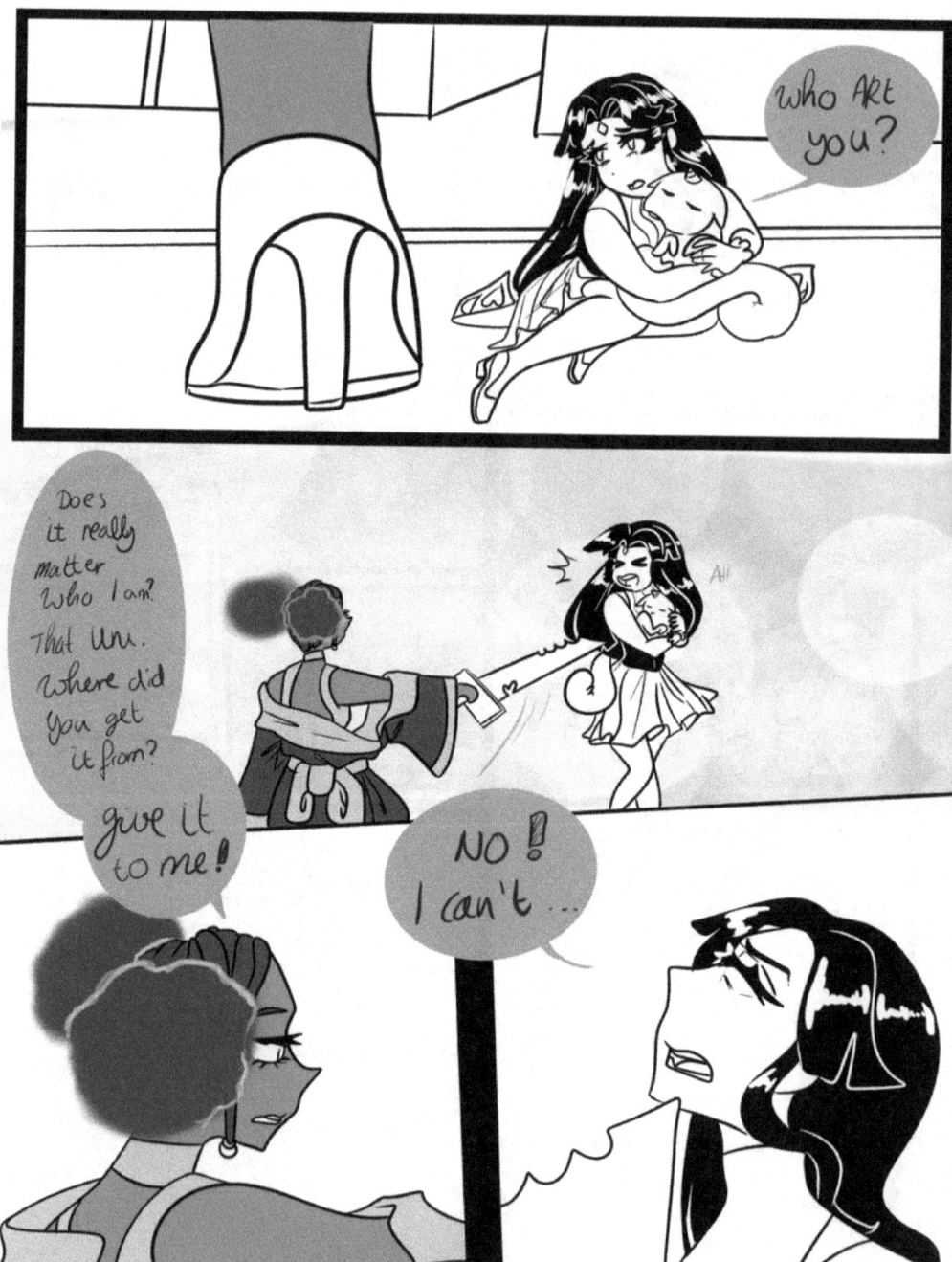

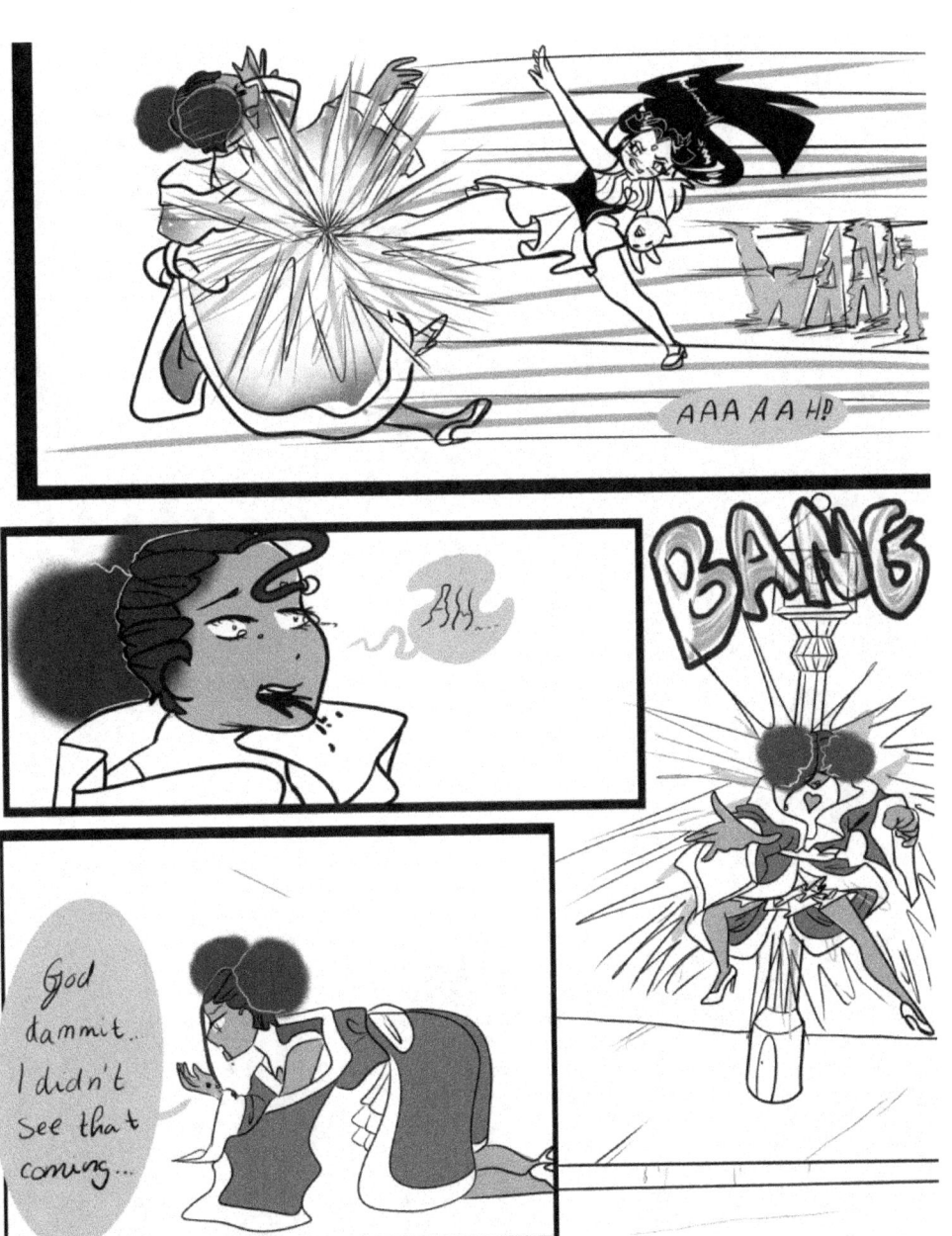

Am I Back Home?

...I want to go Home...

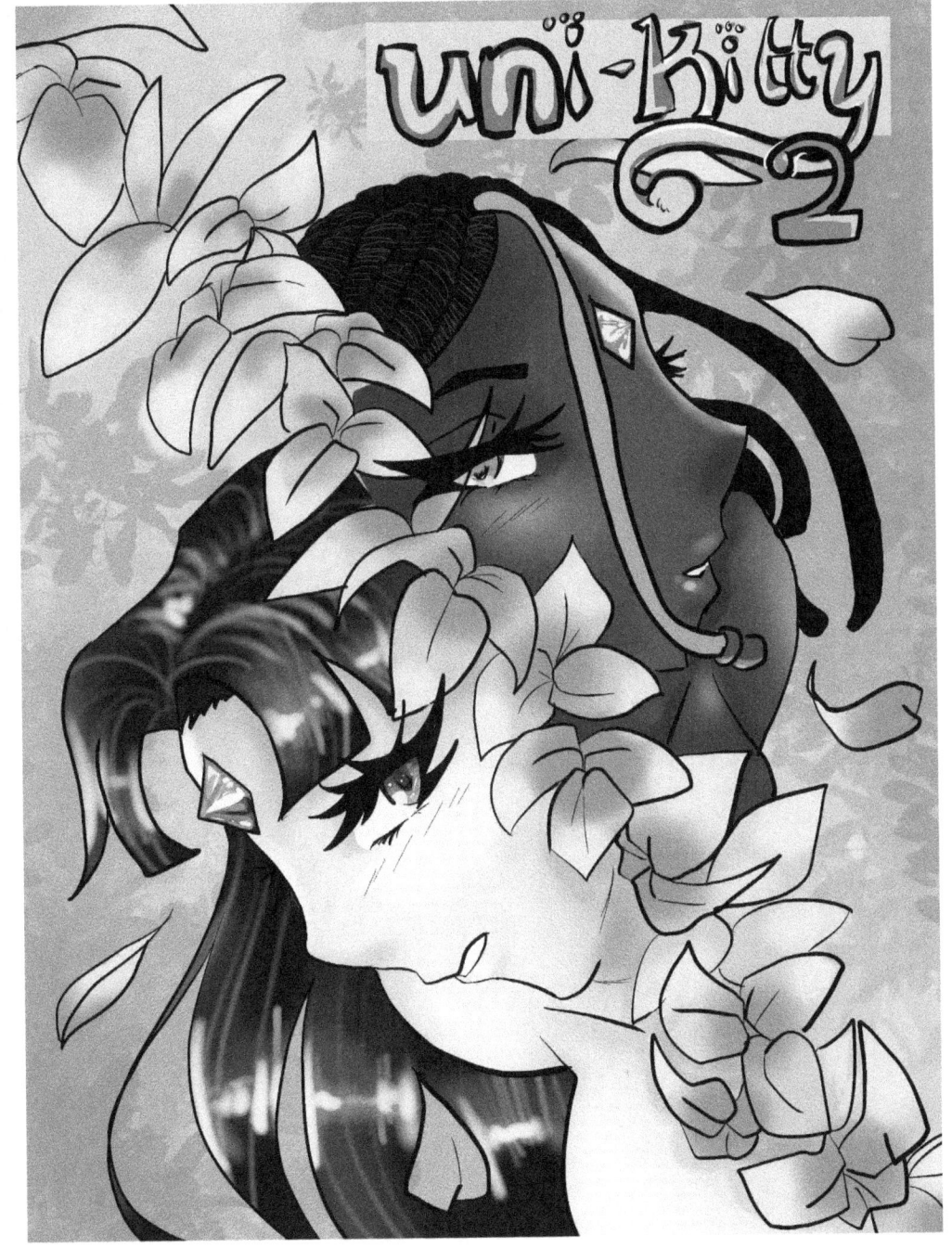

[uni-Kitty] 2

chapter 4 page 4 - 16

Chapter 5 page 17 - 30

Chapter 6 page 31 - 41

Chapter 7 . . . page 42 - 56

writers note . . page 56 - 58

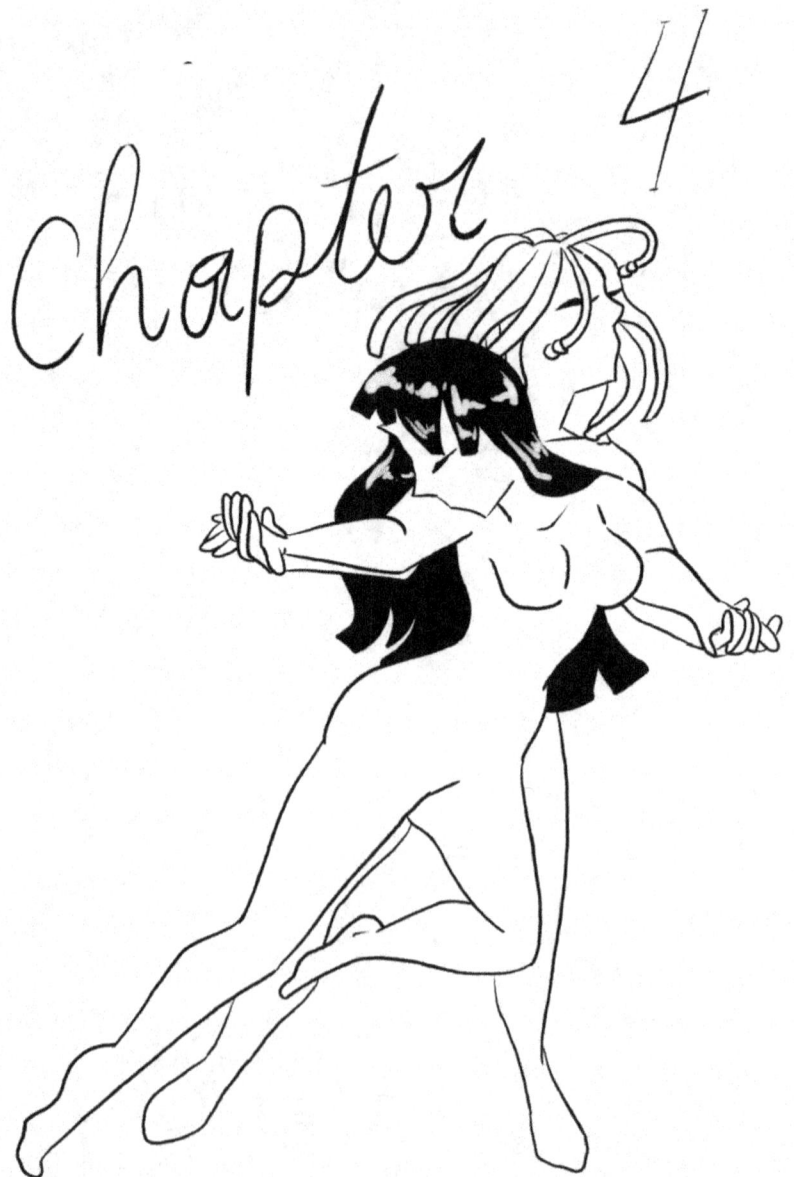

"She got away, with the other uni..." "I know that. Look I can't go after them without knowing more..."

"Will you go..."

"No. She's ecless. Do you think that they even know what we are fighting? ...No"

"We will go after them when I know more."

The other uni feels familliar.

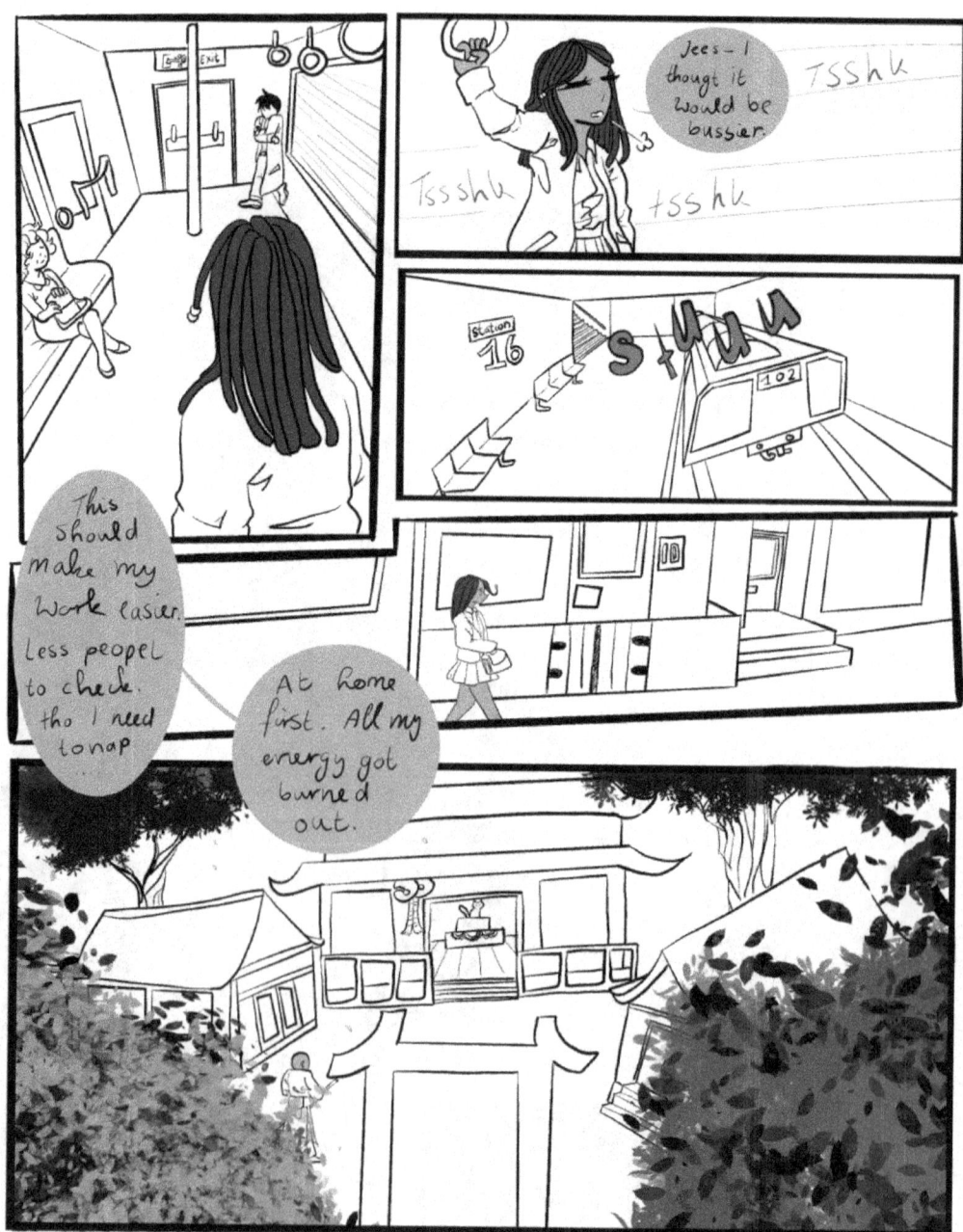

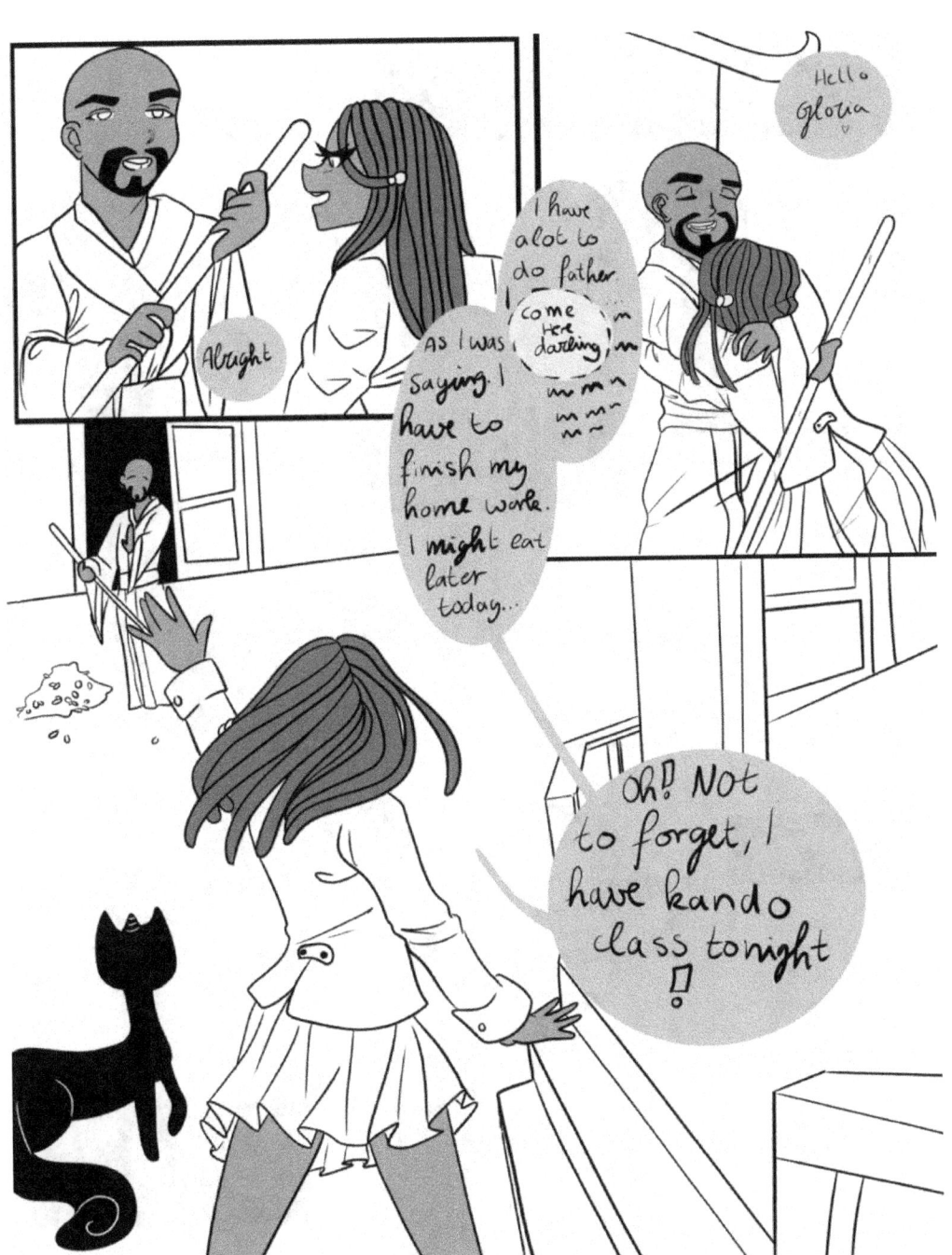

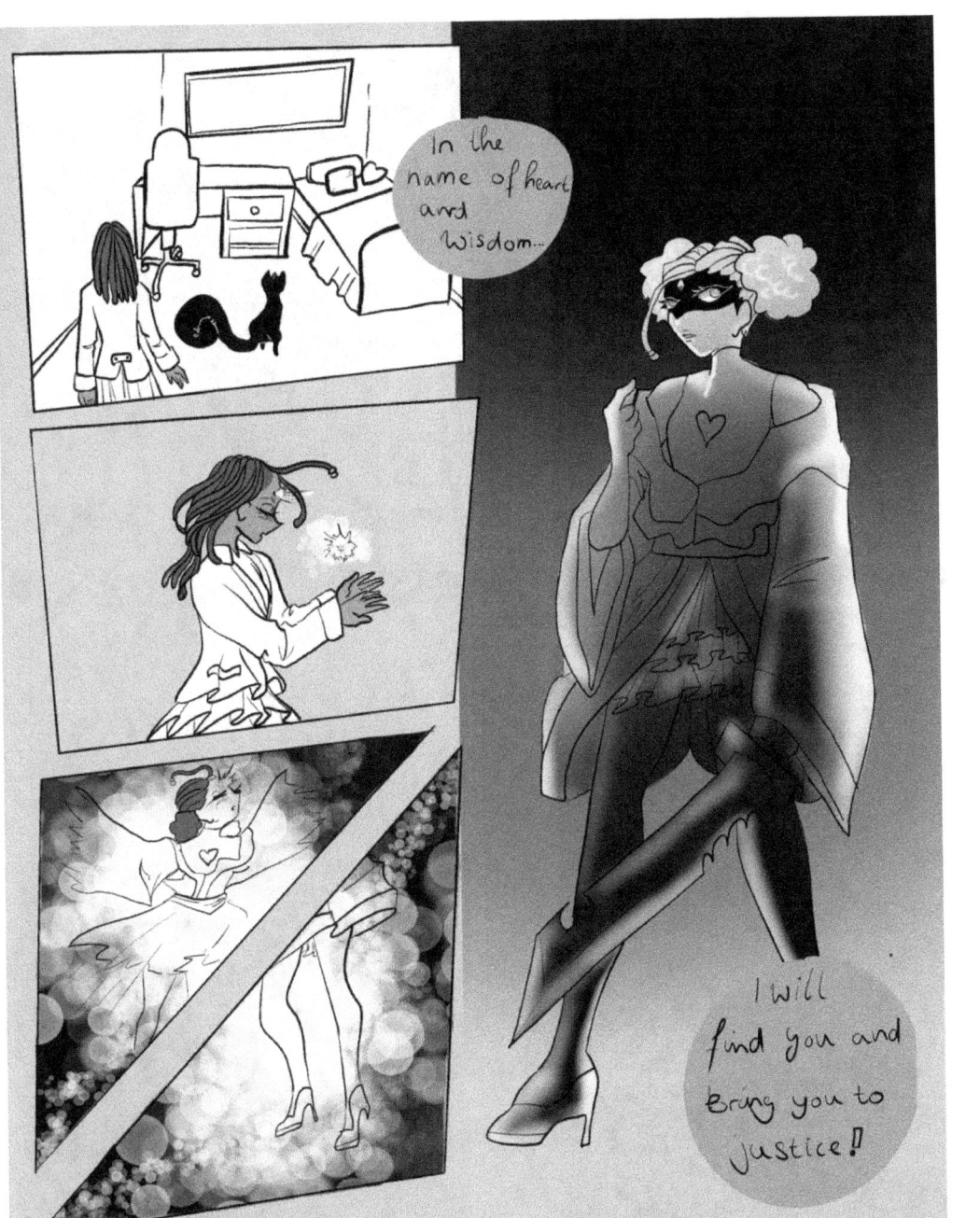

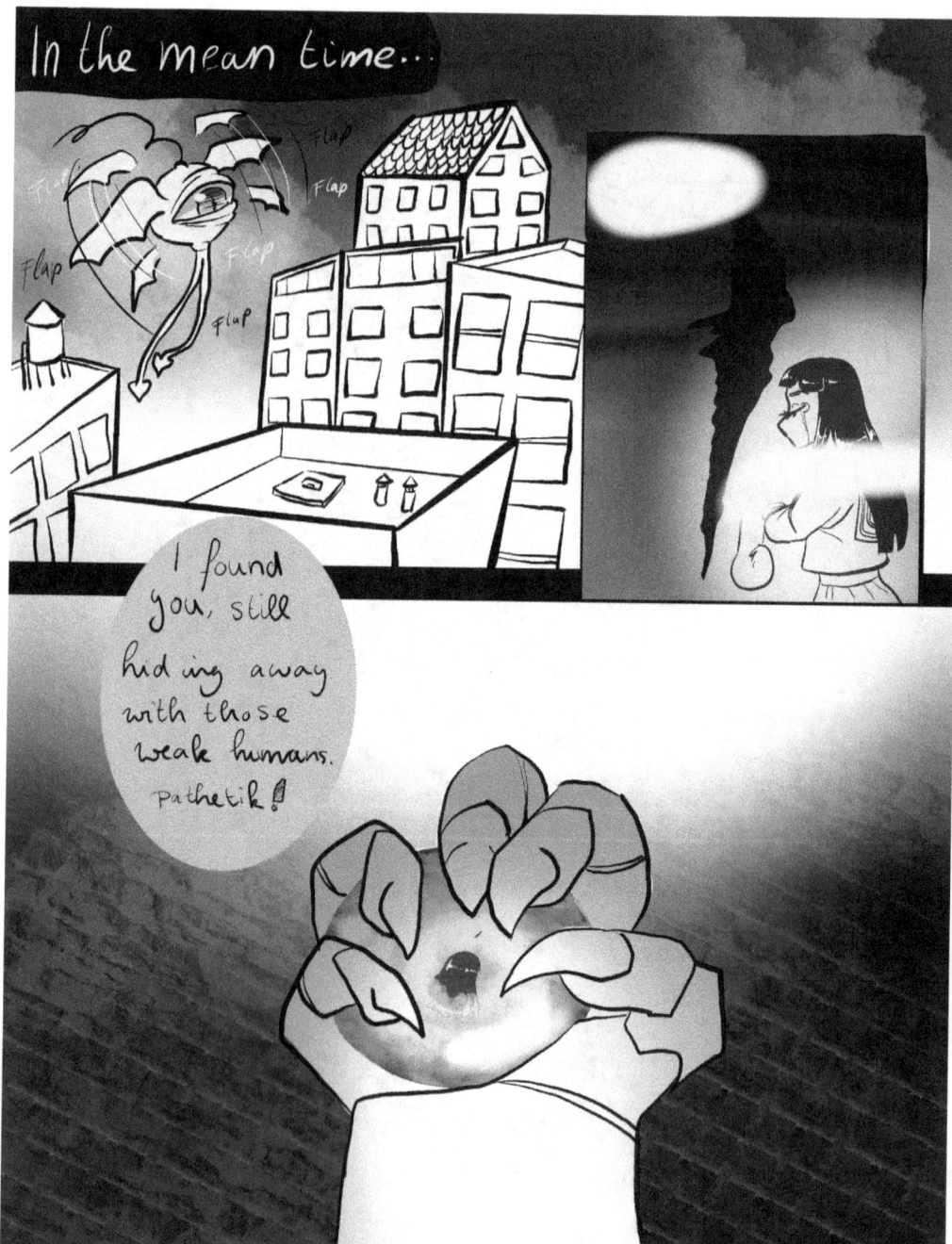

"I'm so scared. Why is this happening?..."

"...I need help. He's hurt... I... I don't know what to do..."

"What...?"

"Where do I go?"

Umi? Take me home. The darkness is coming...

I feel a bit better.

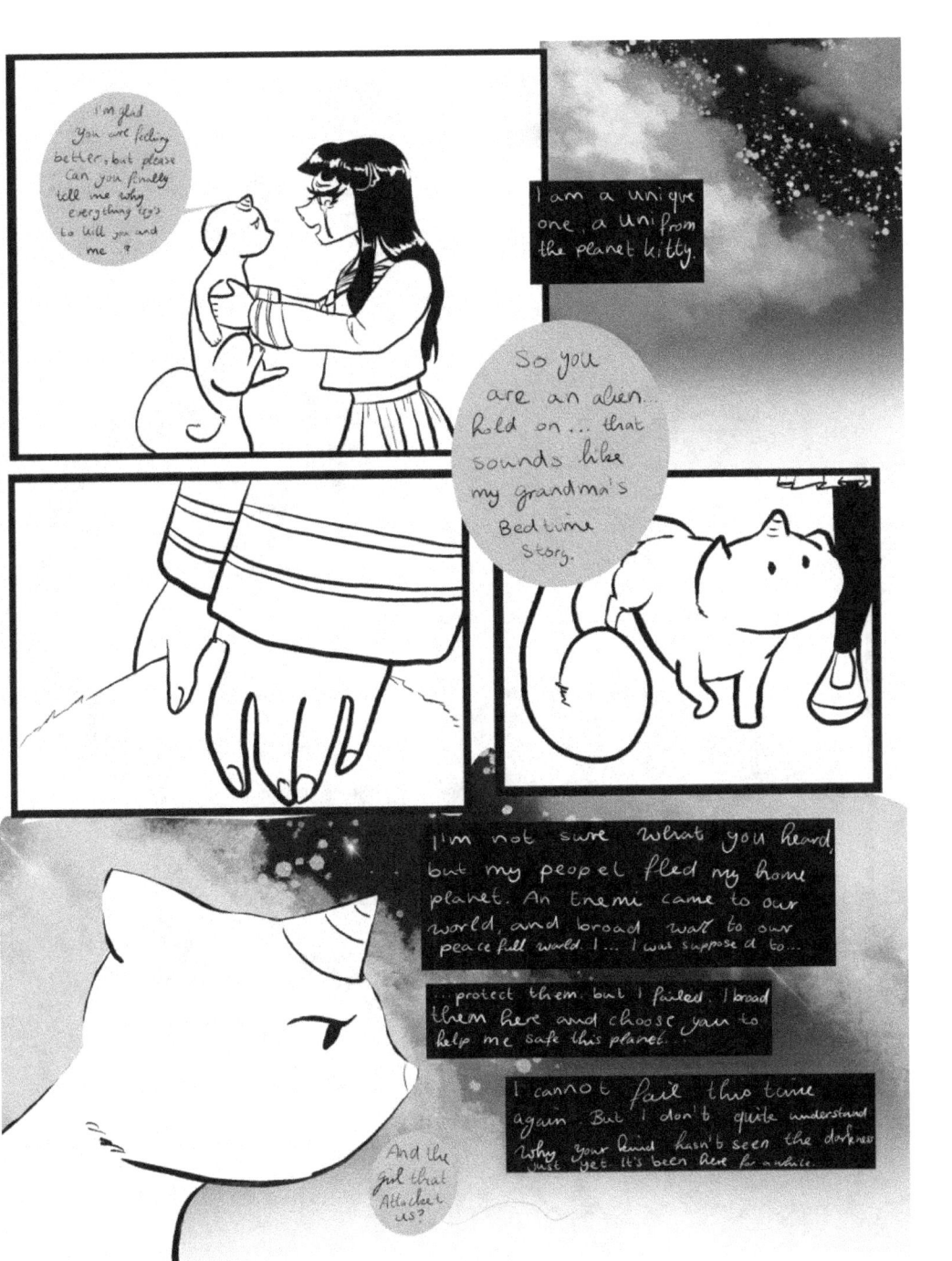

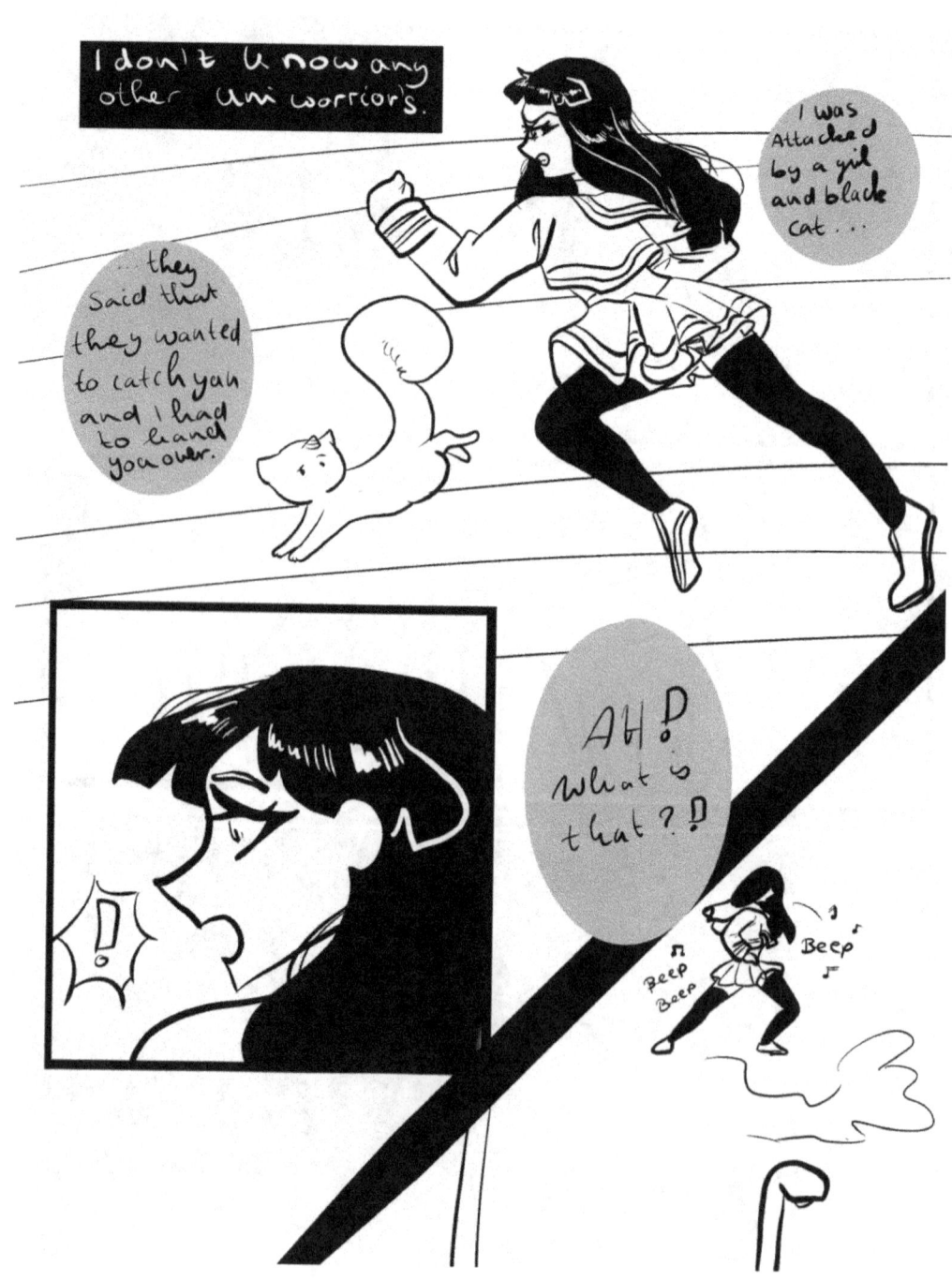

Chapter 5

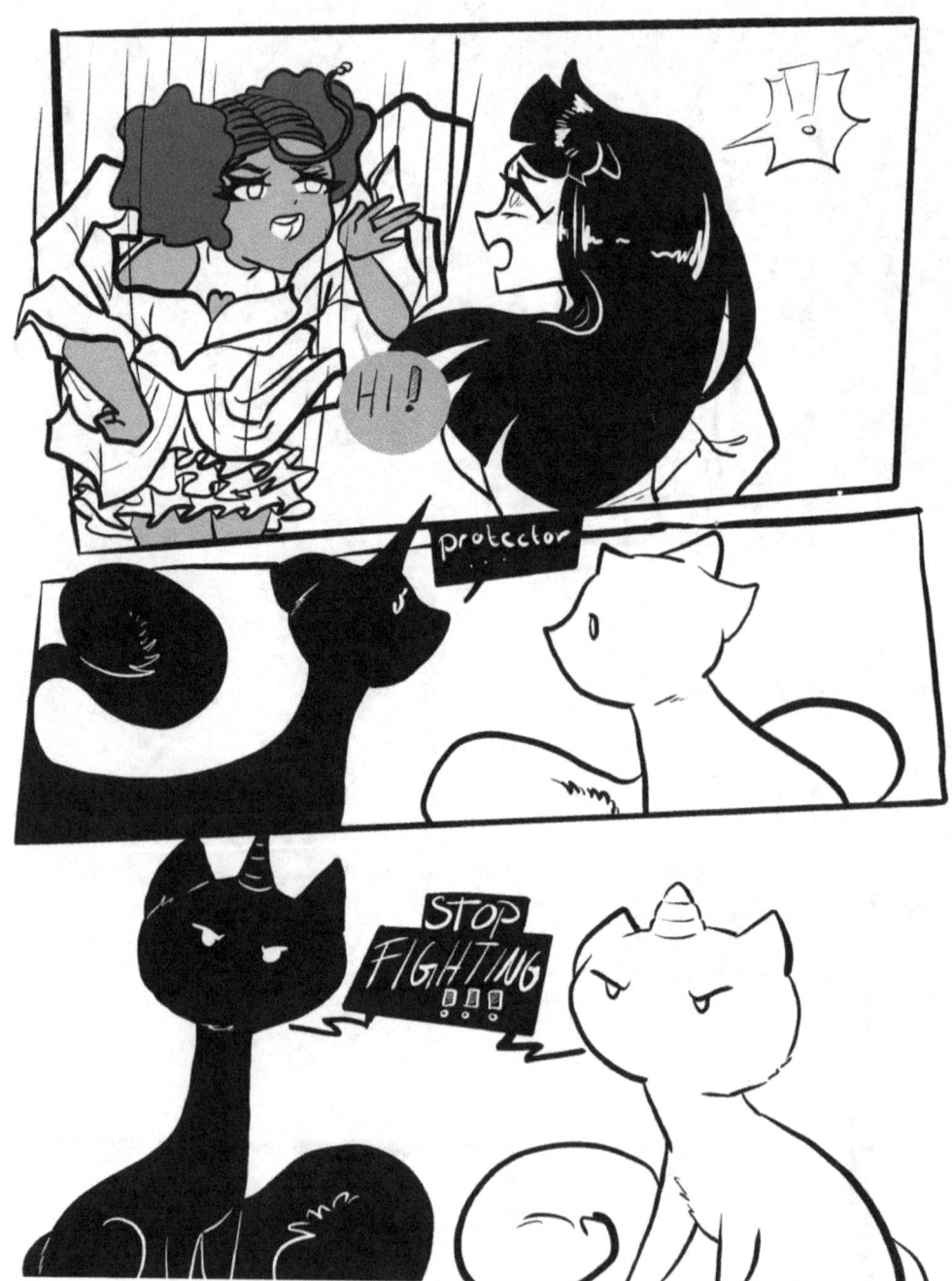

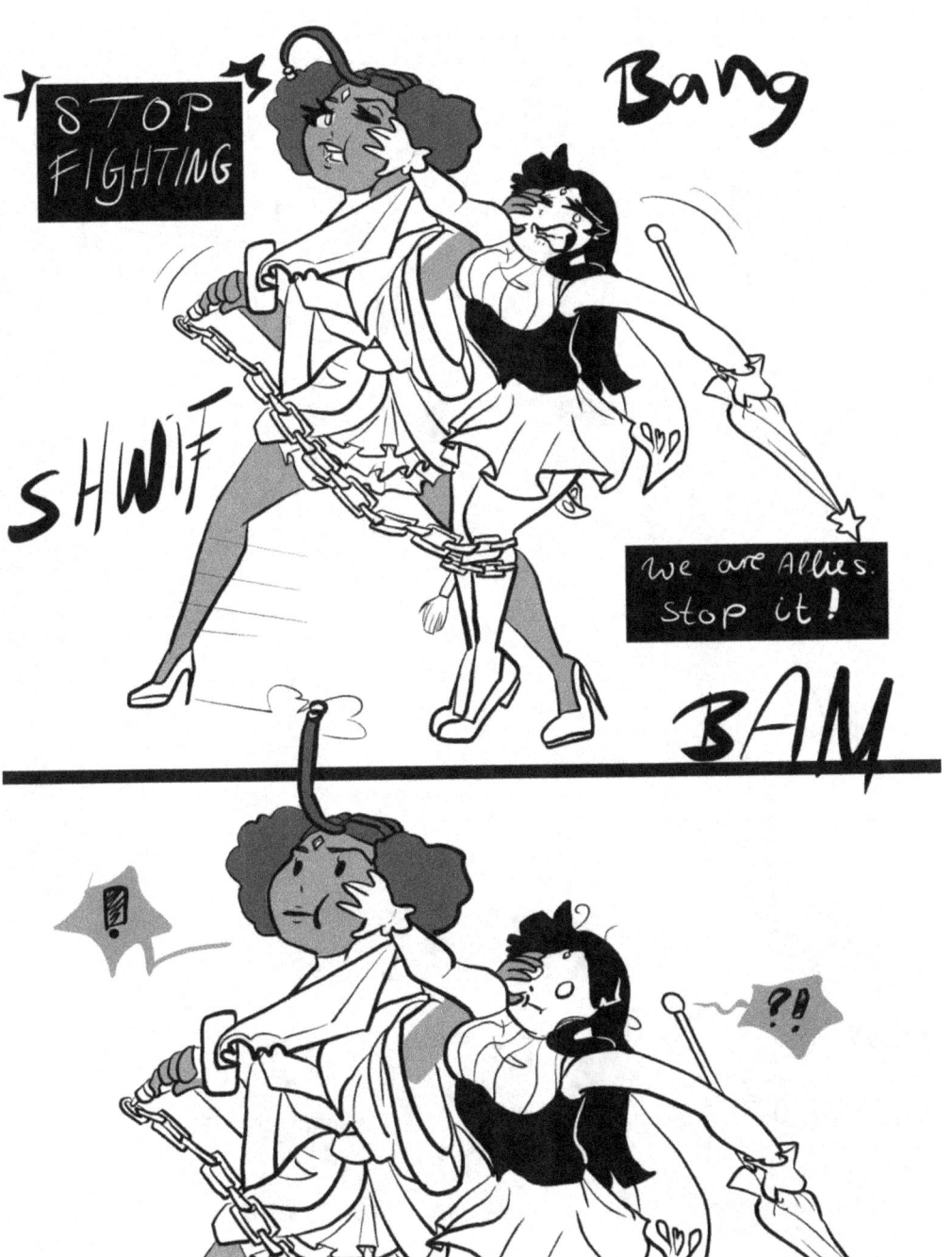

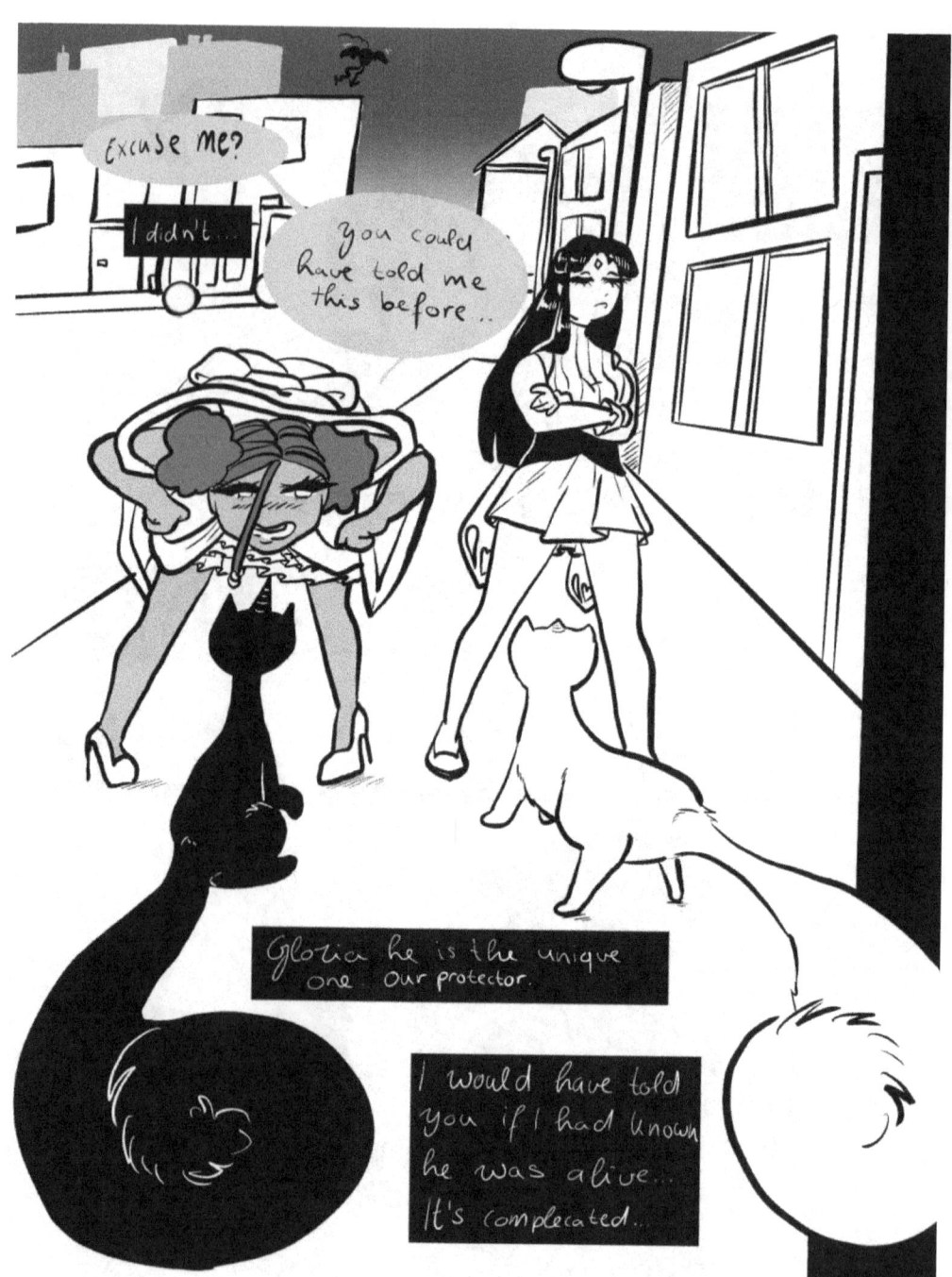

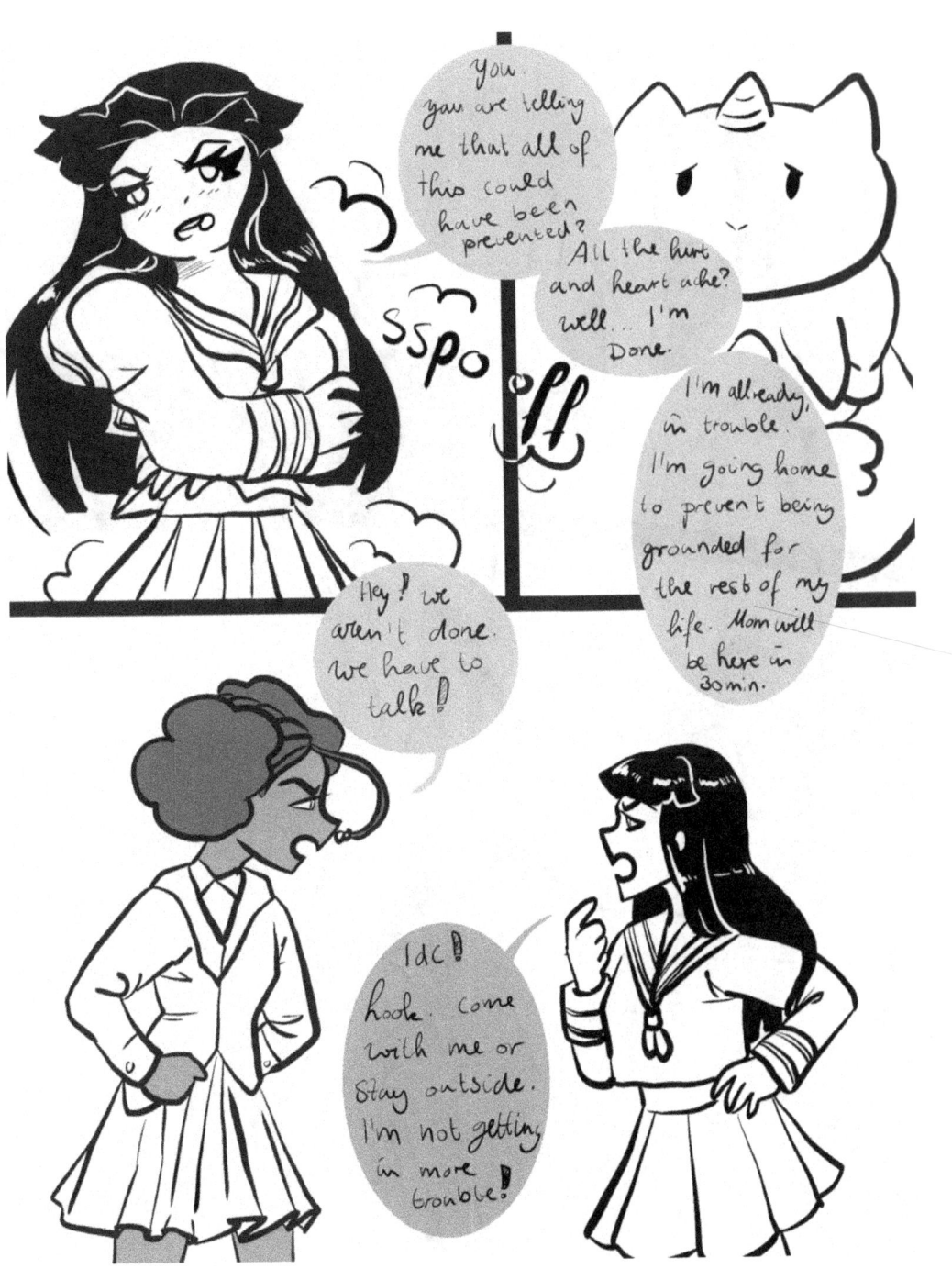

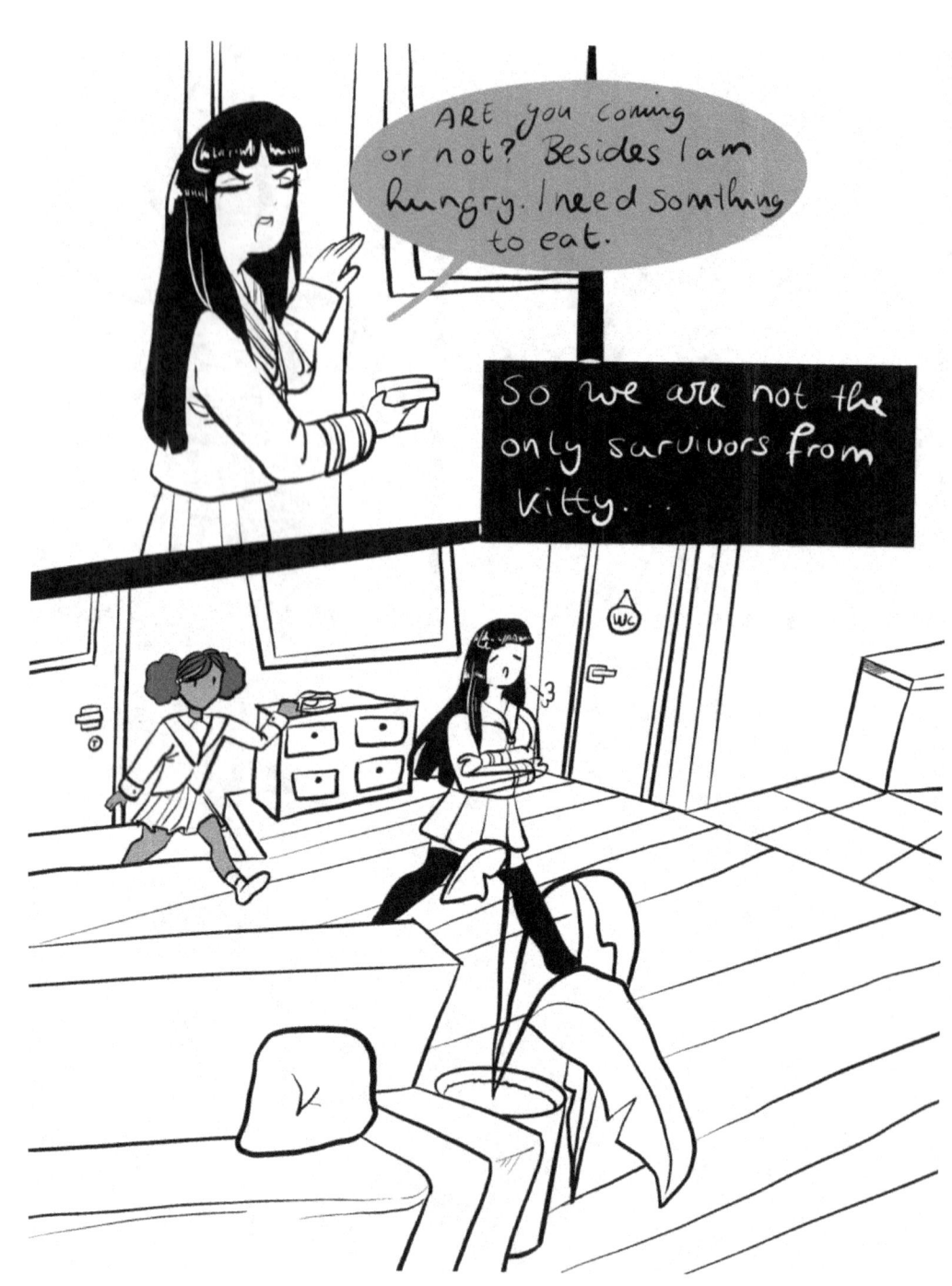

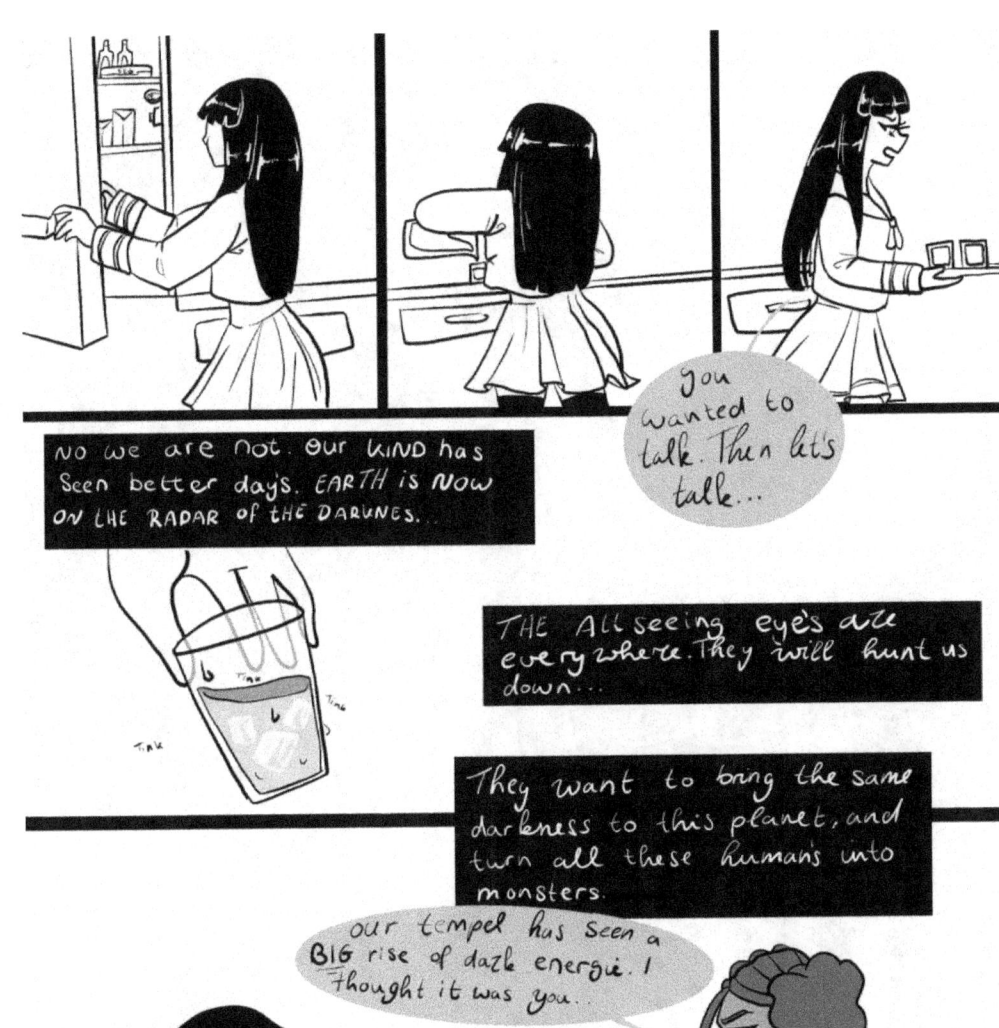

NO! I didn't bring doom! I wanted to protect my peopel... I ... I really wanted to protect them.

BAAM

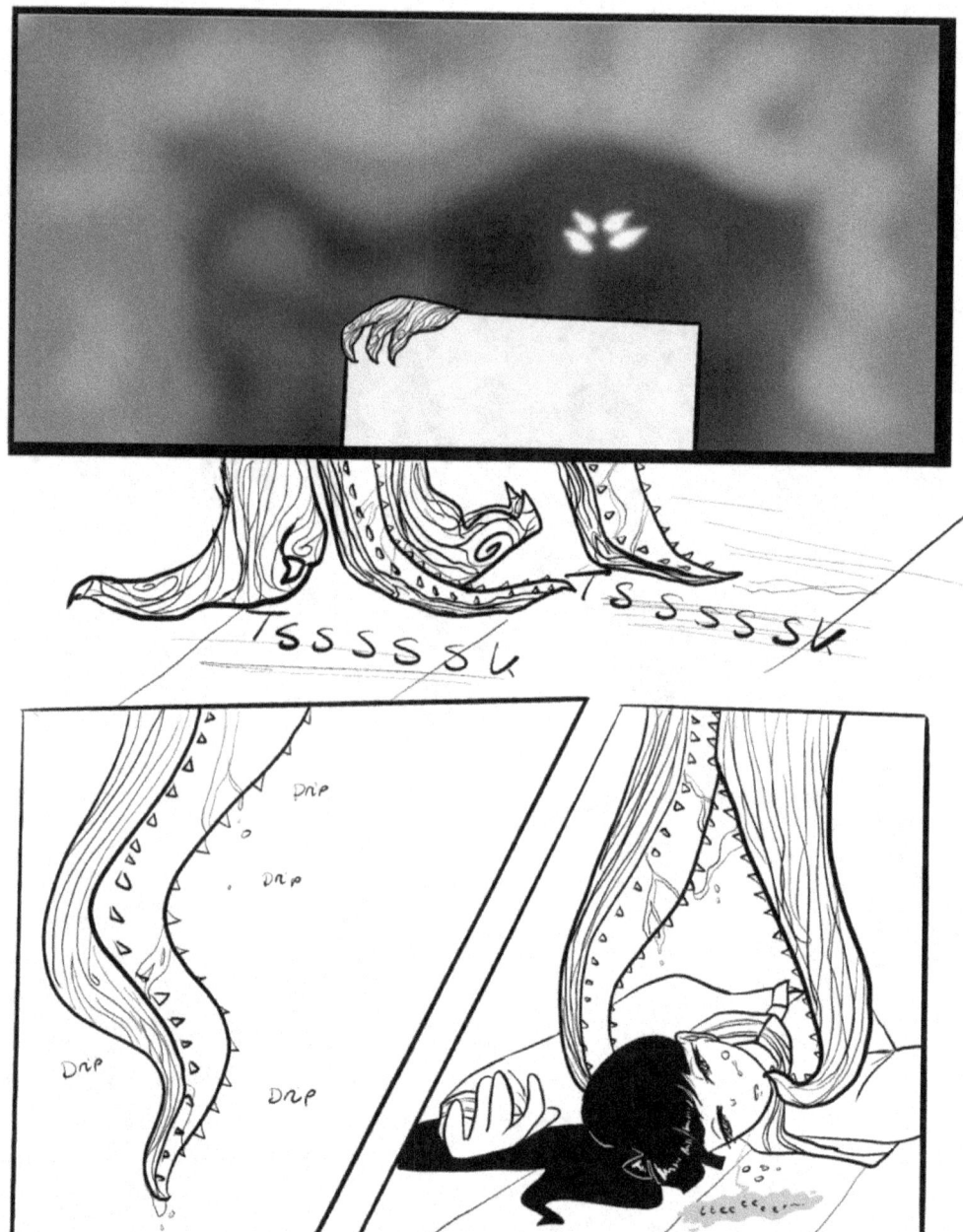

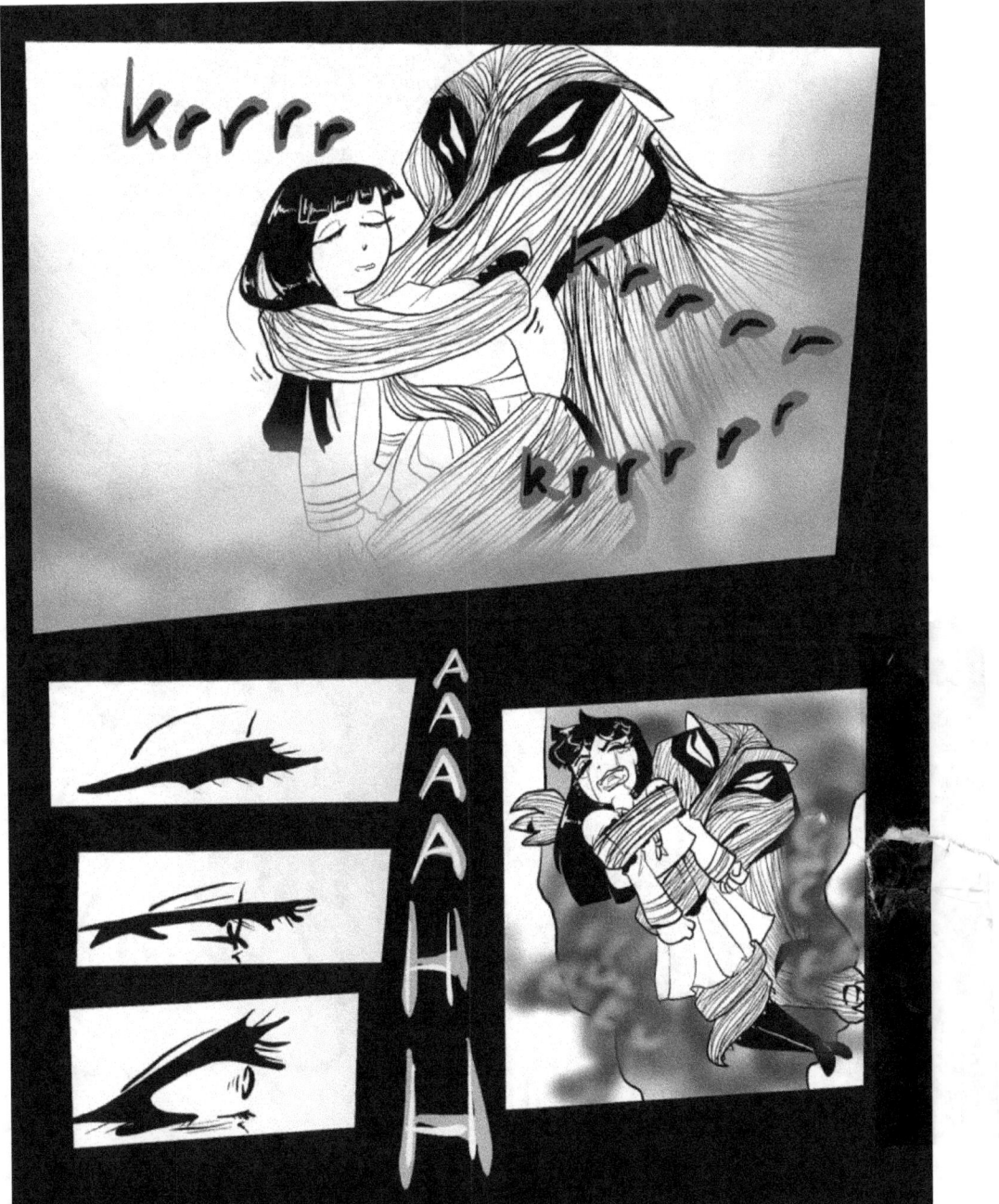

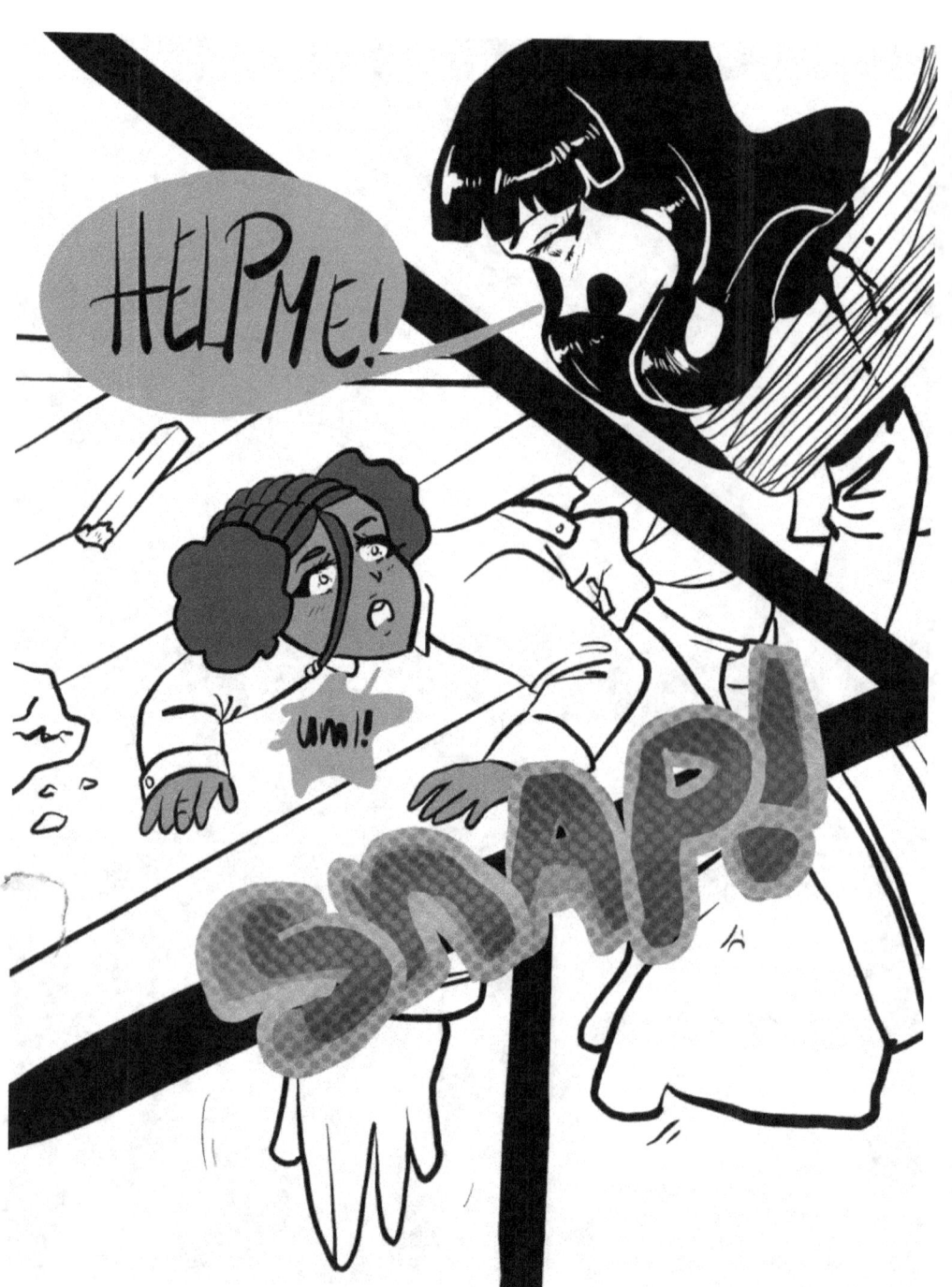

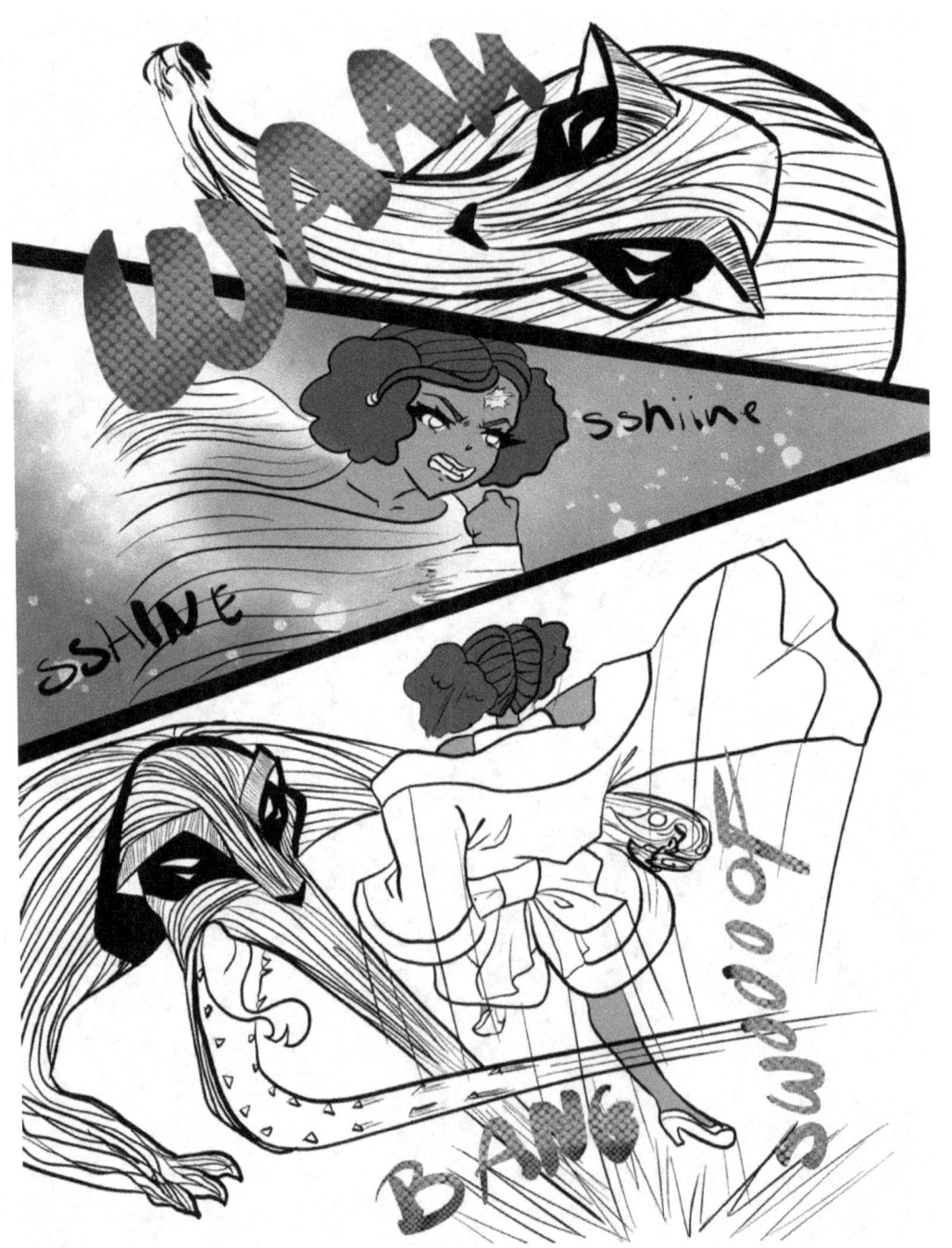

Chapter 6

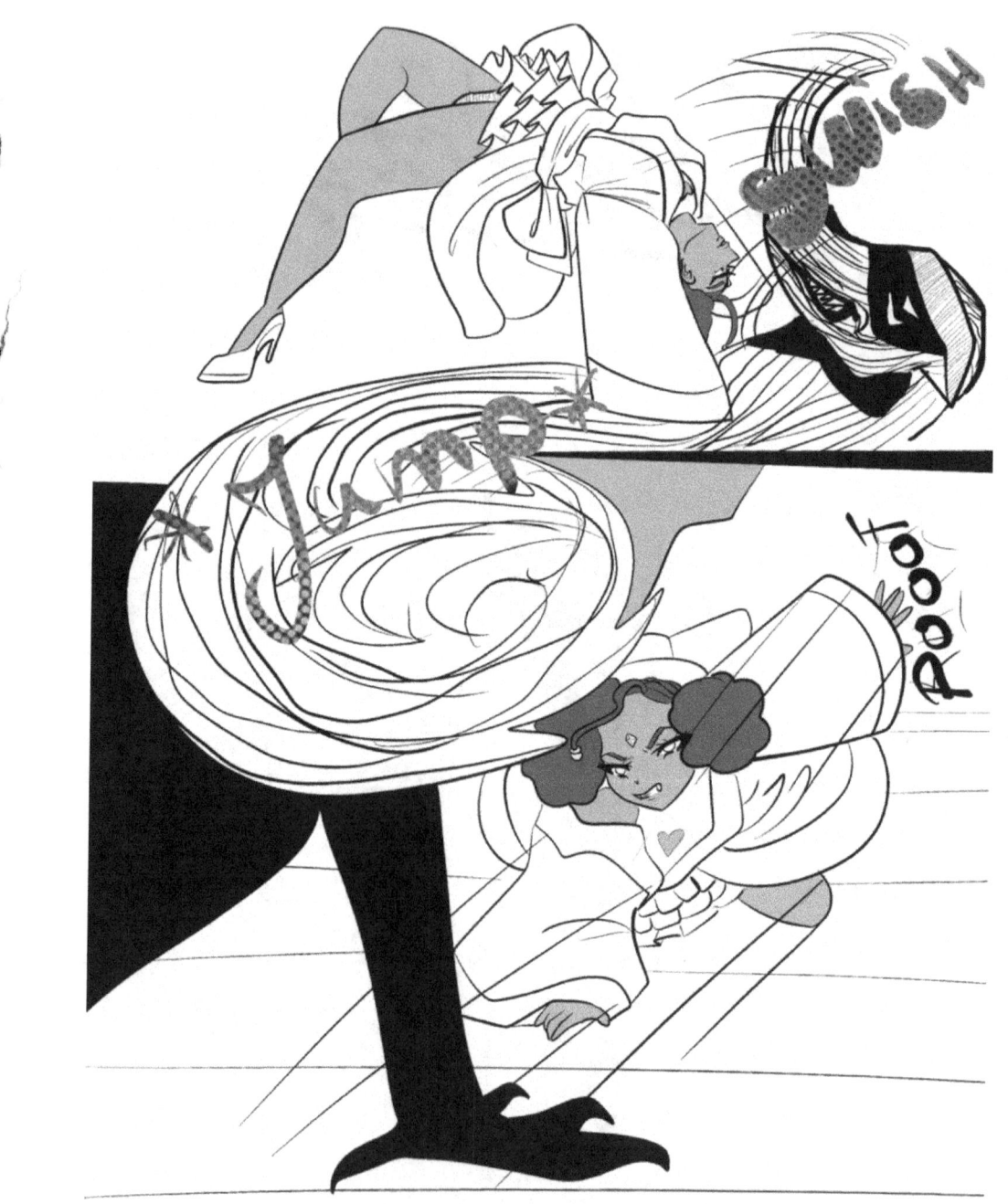

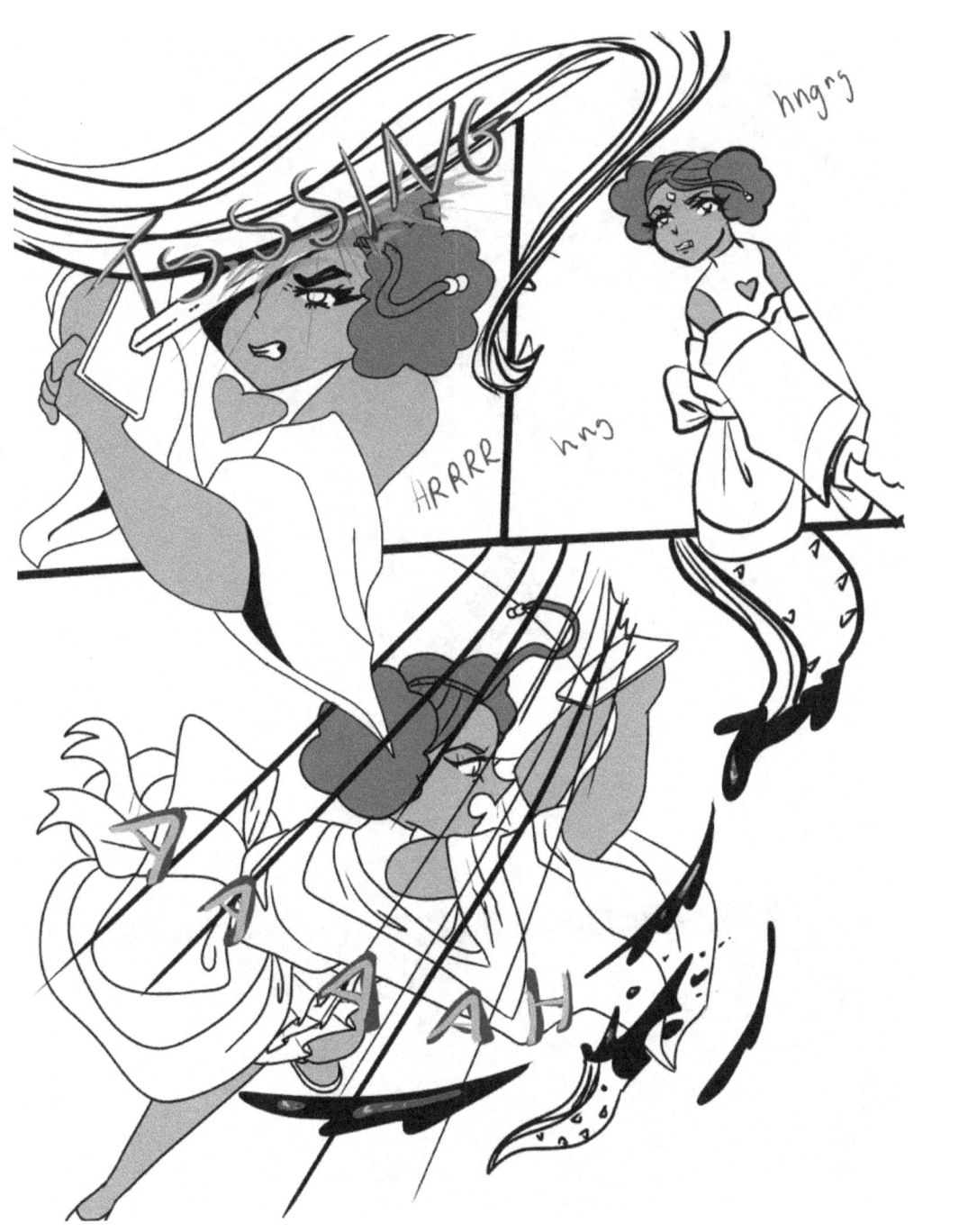

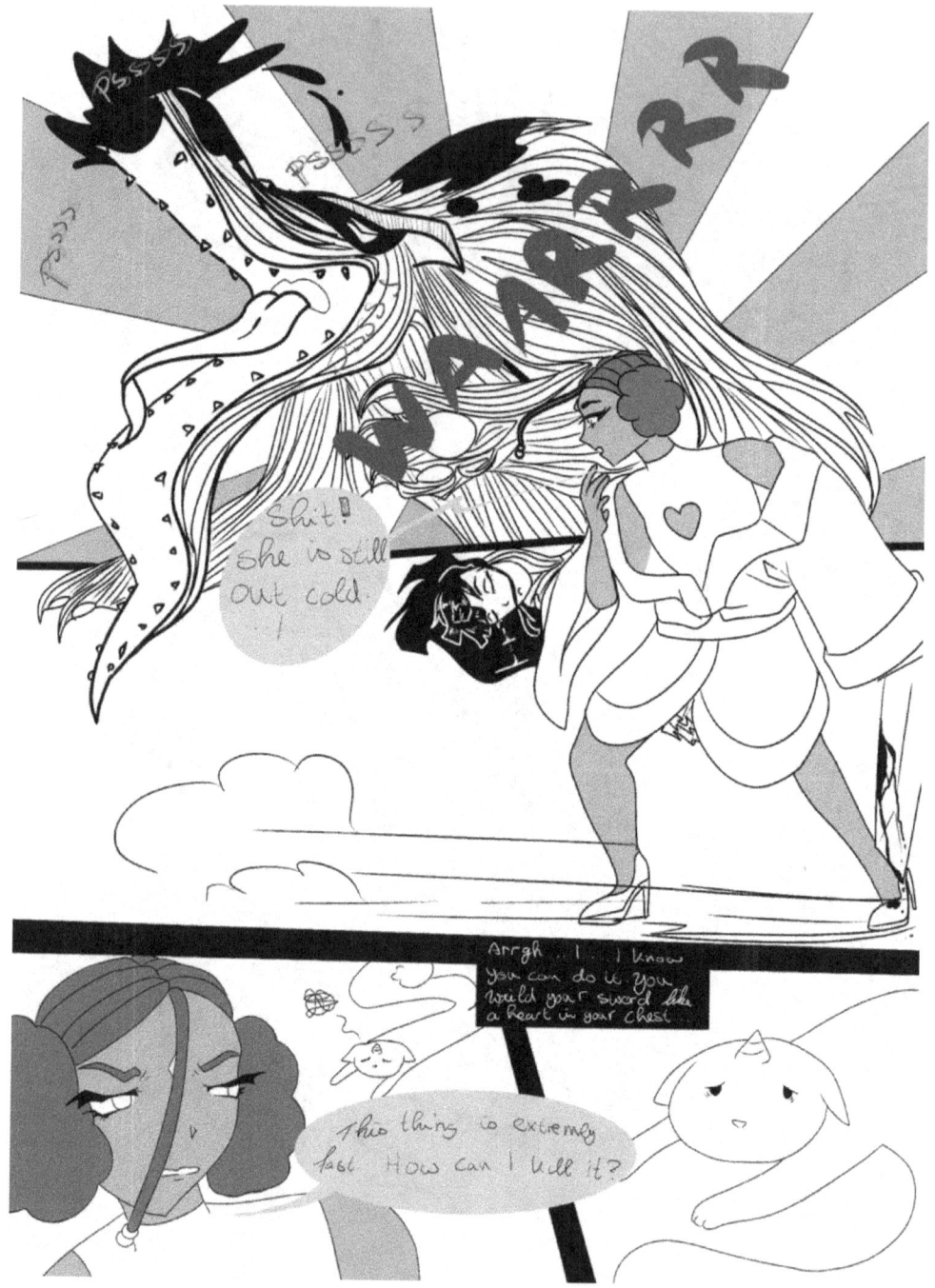

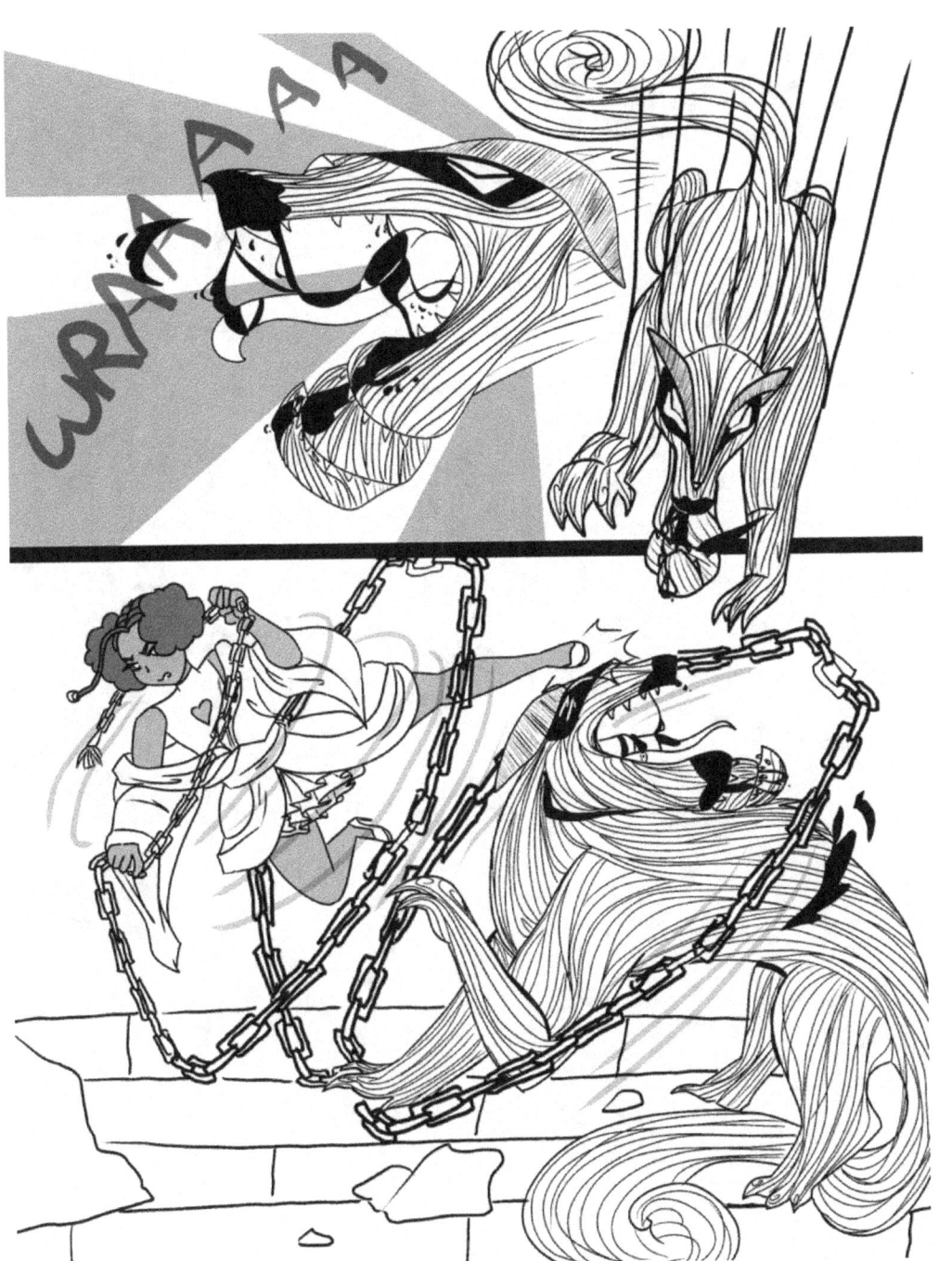

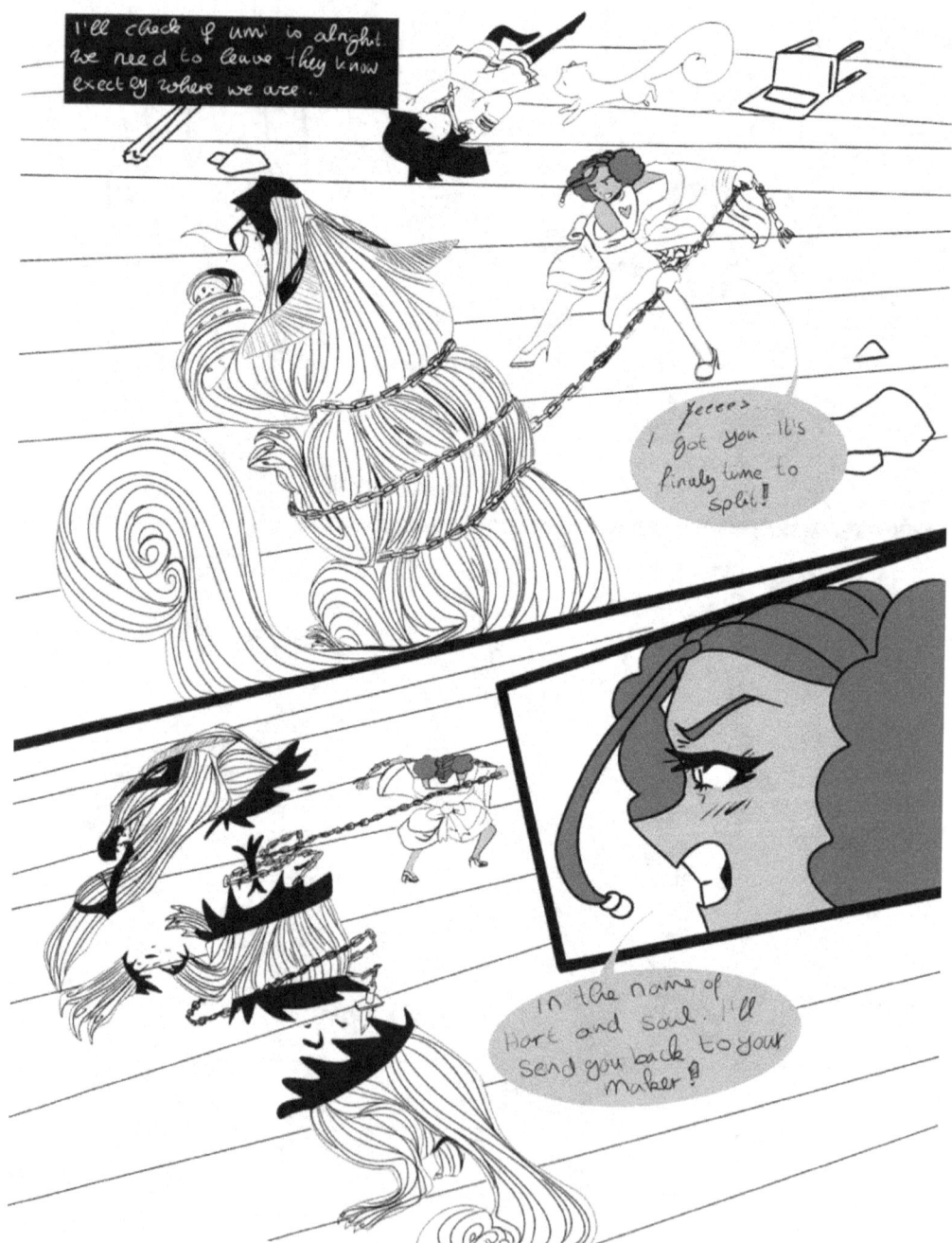

I can feel a heart... I haven't felt a heart...

for so long... am I dreaming?

I've been so alone for so long...

Am I free...?

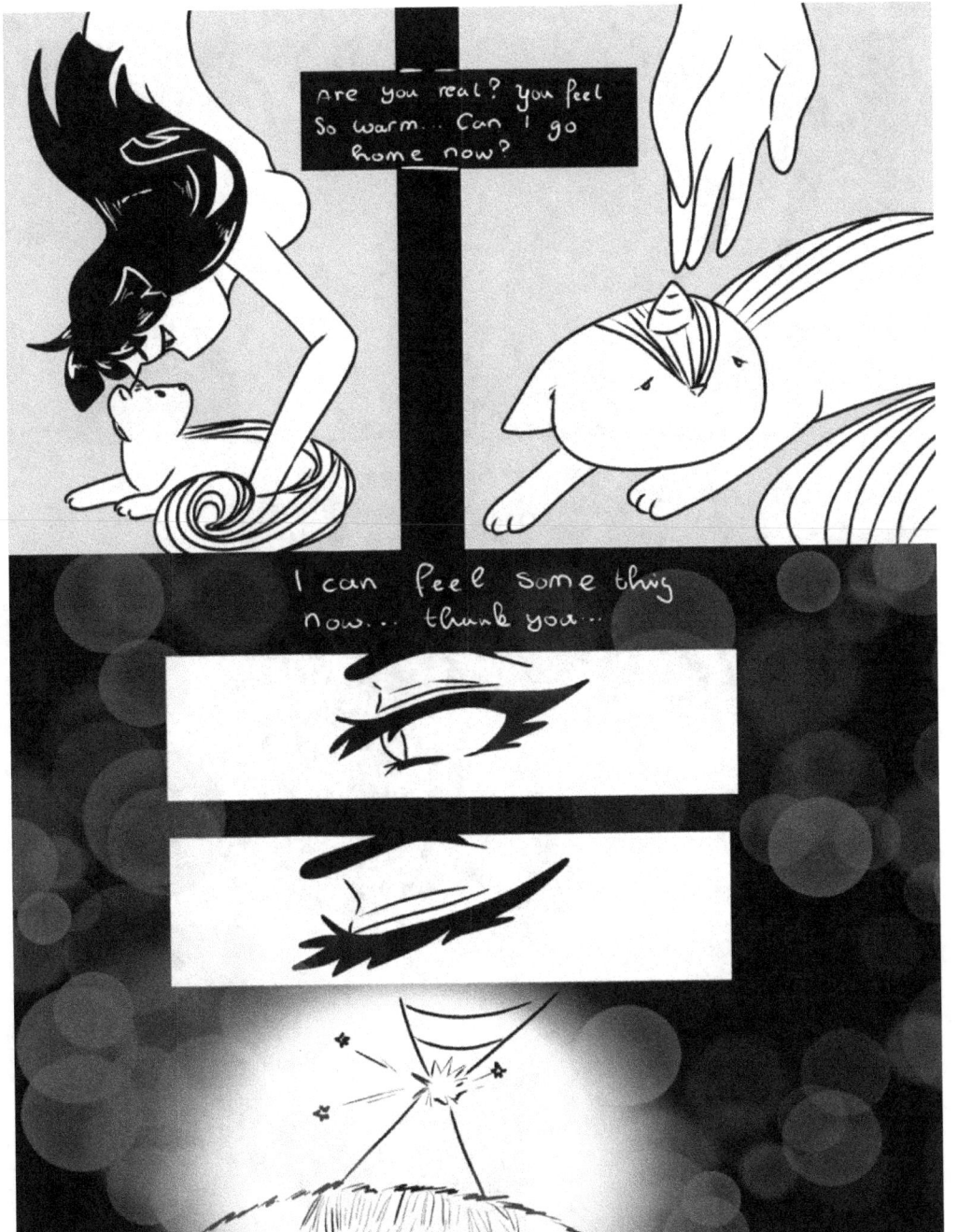

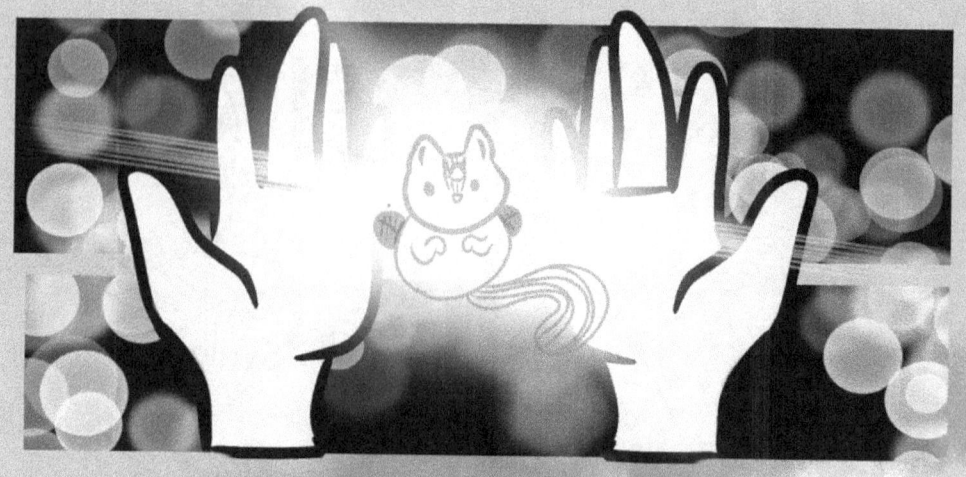

Chapter 7

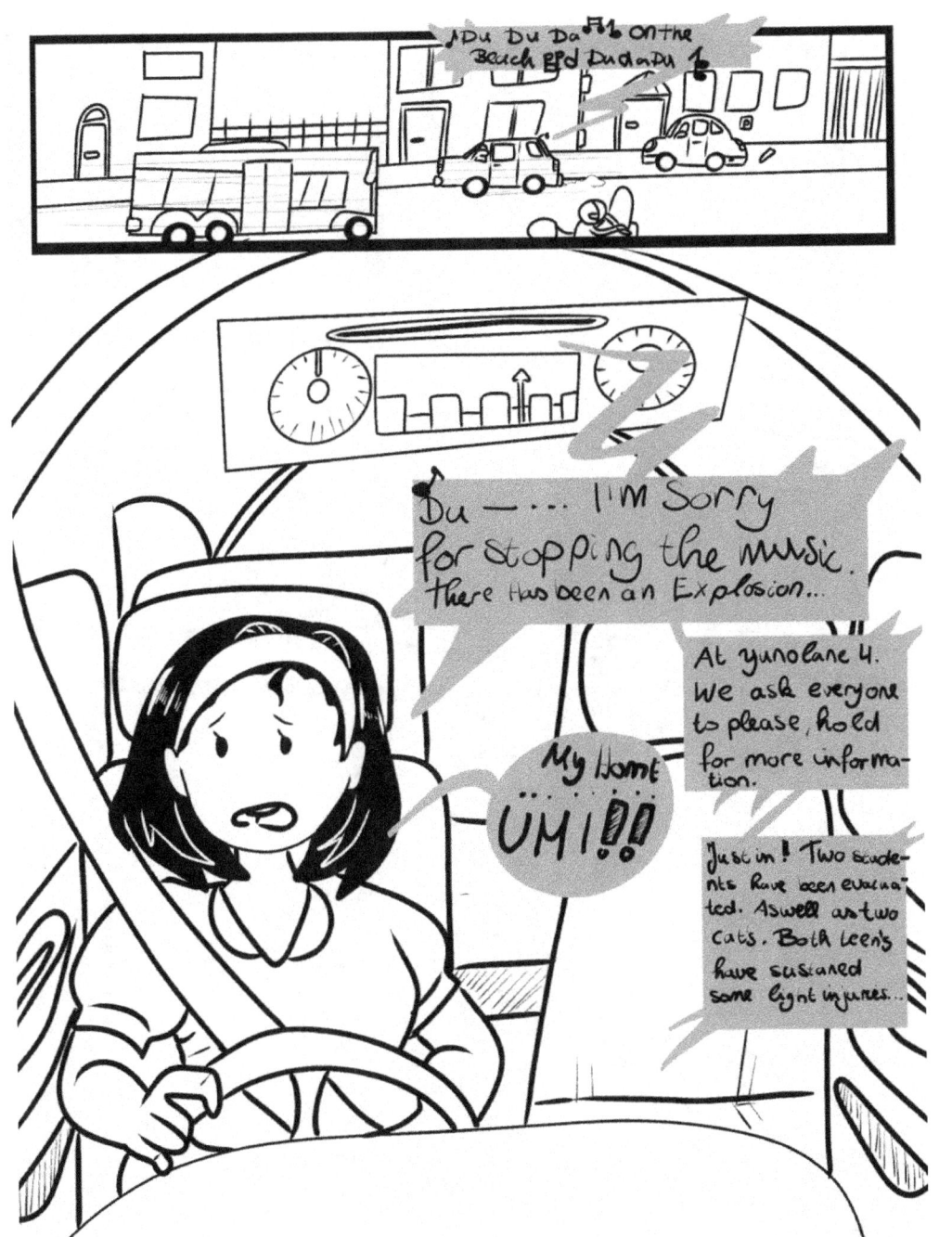

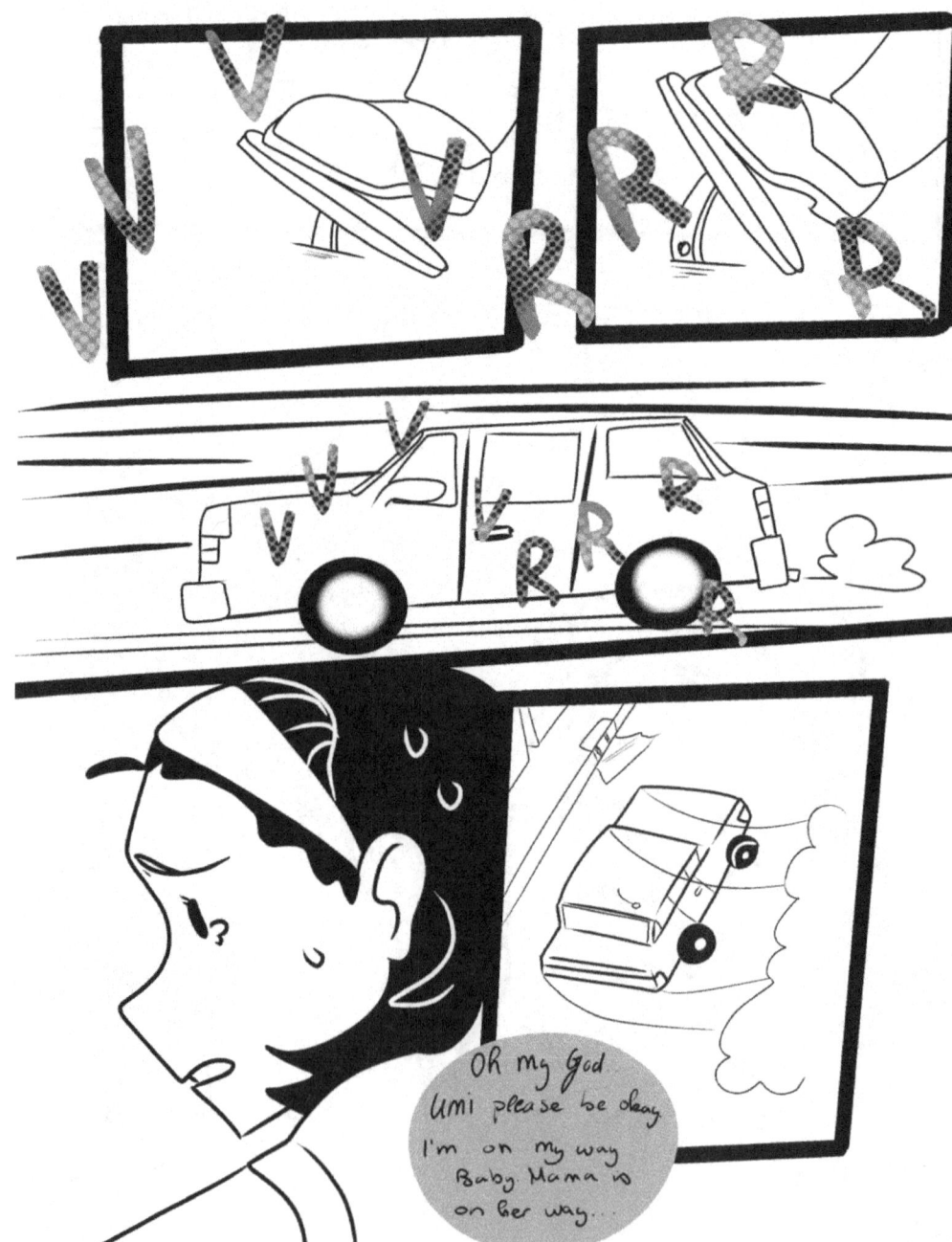

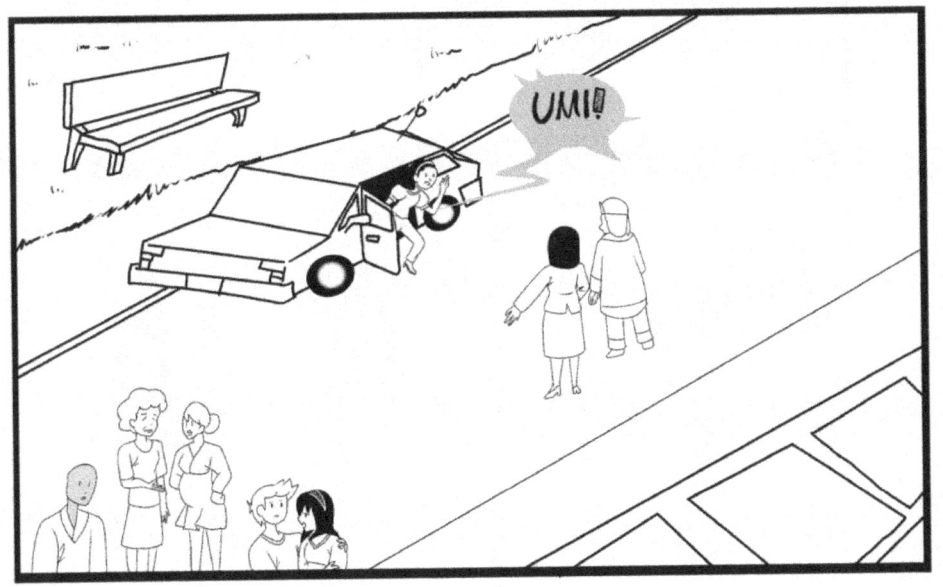

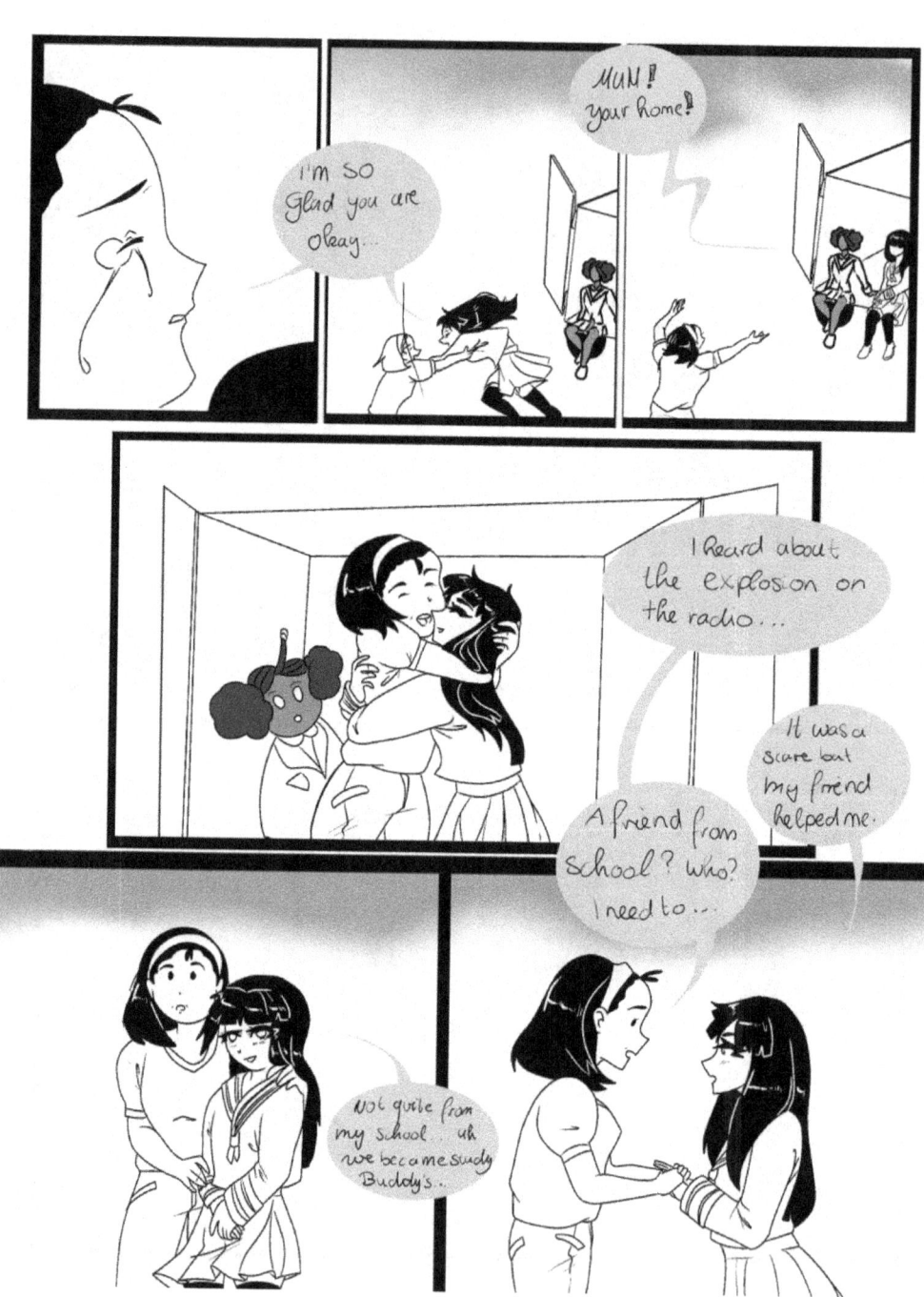

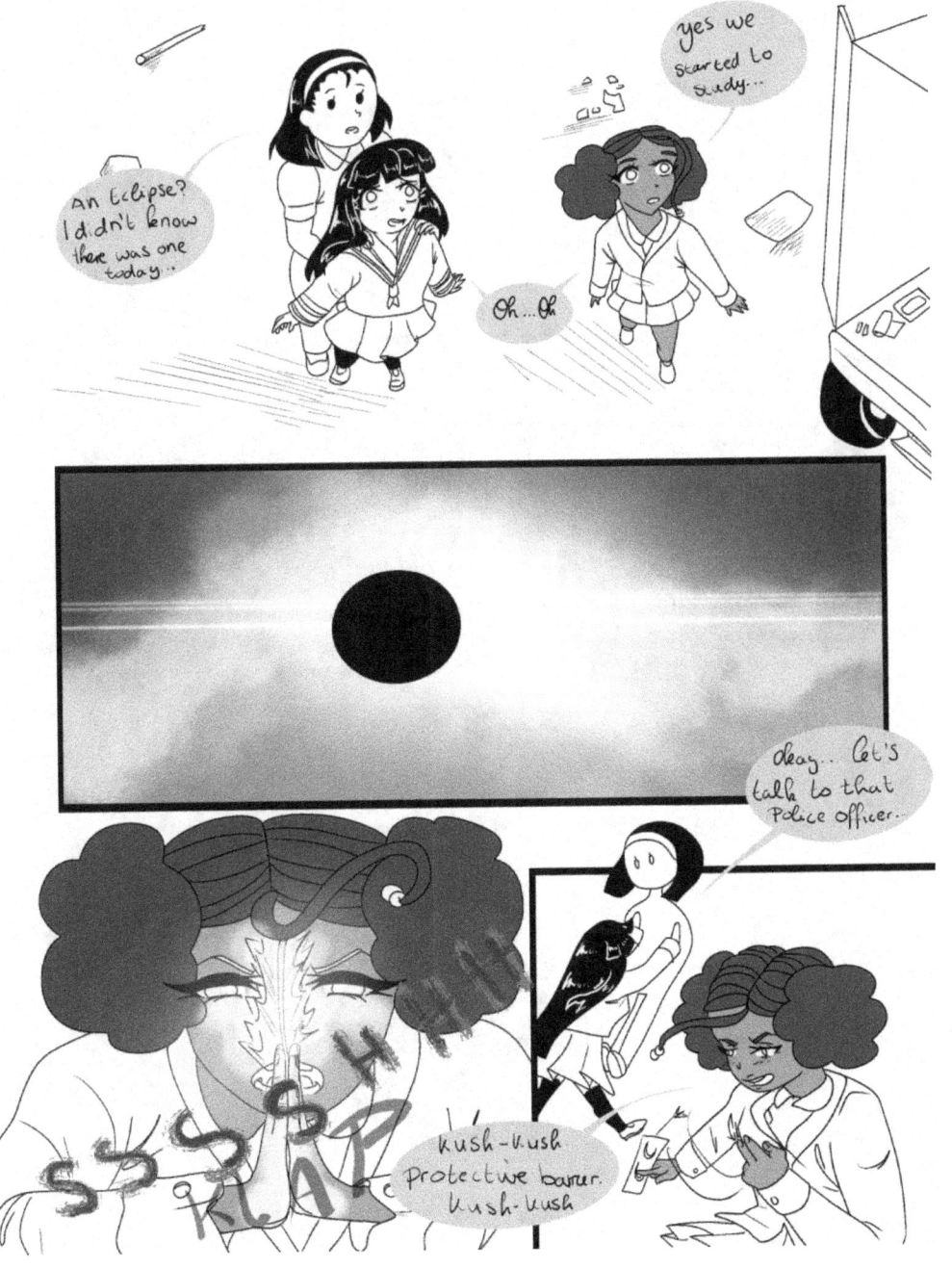

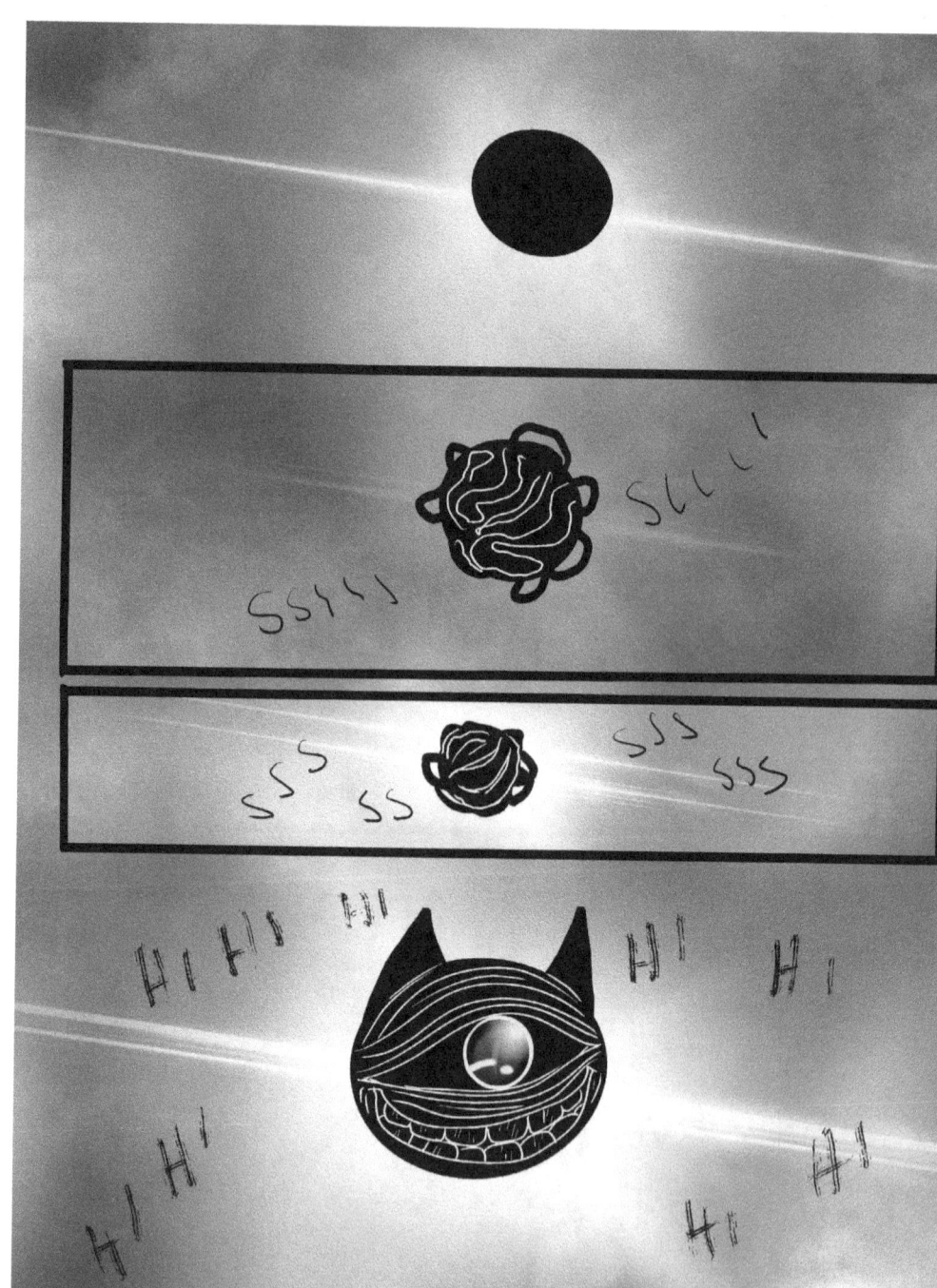

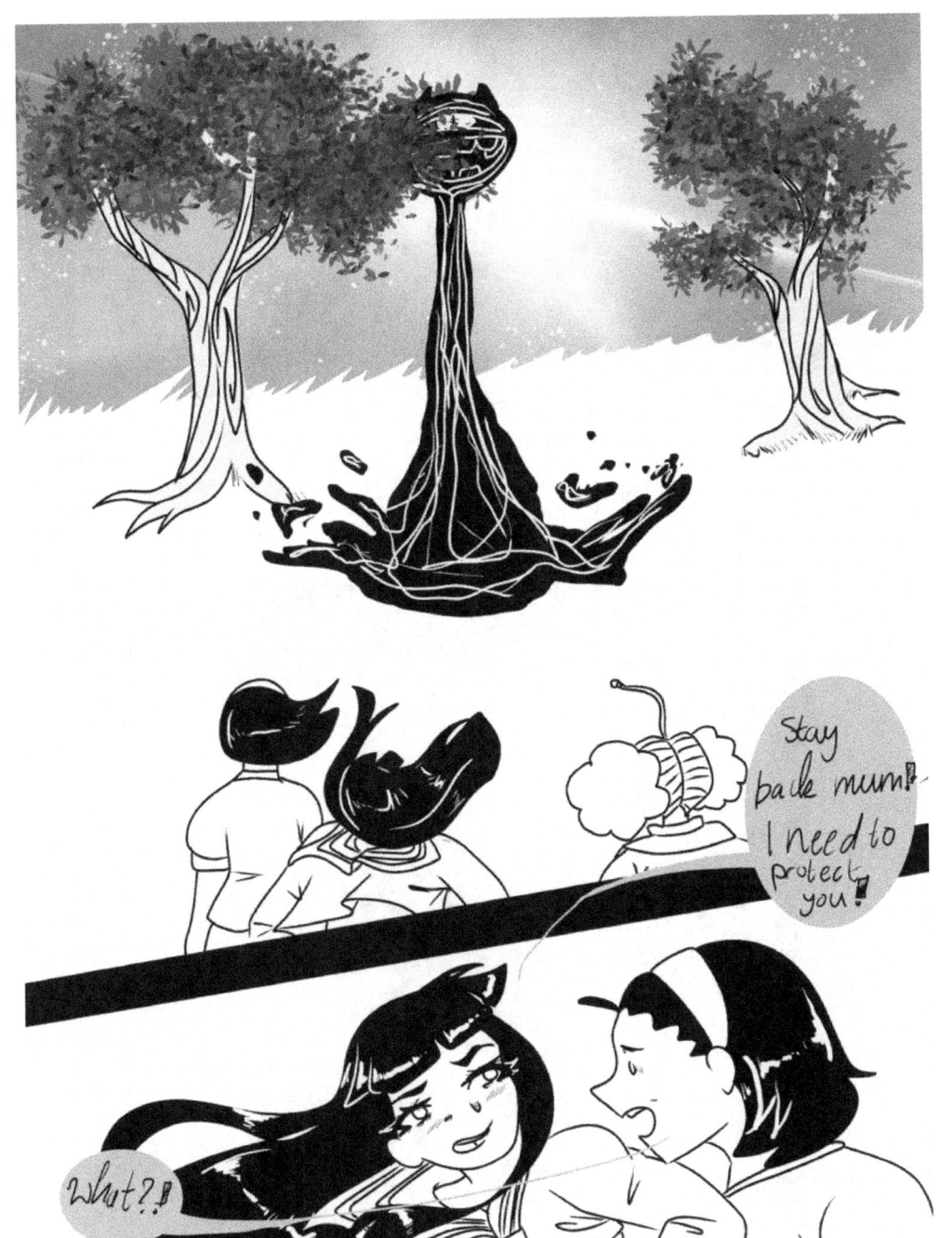

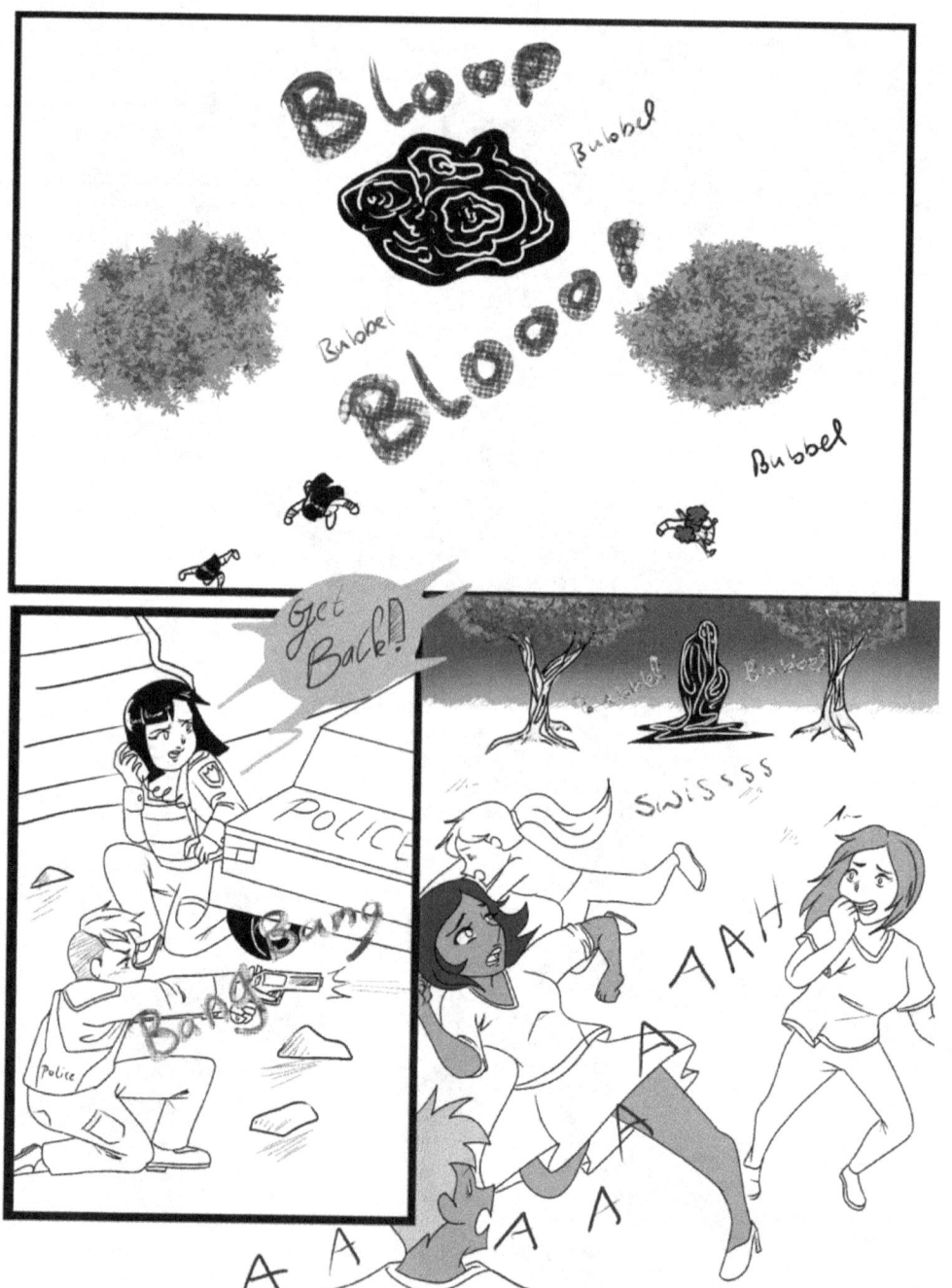

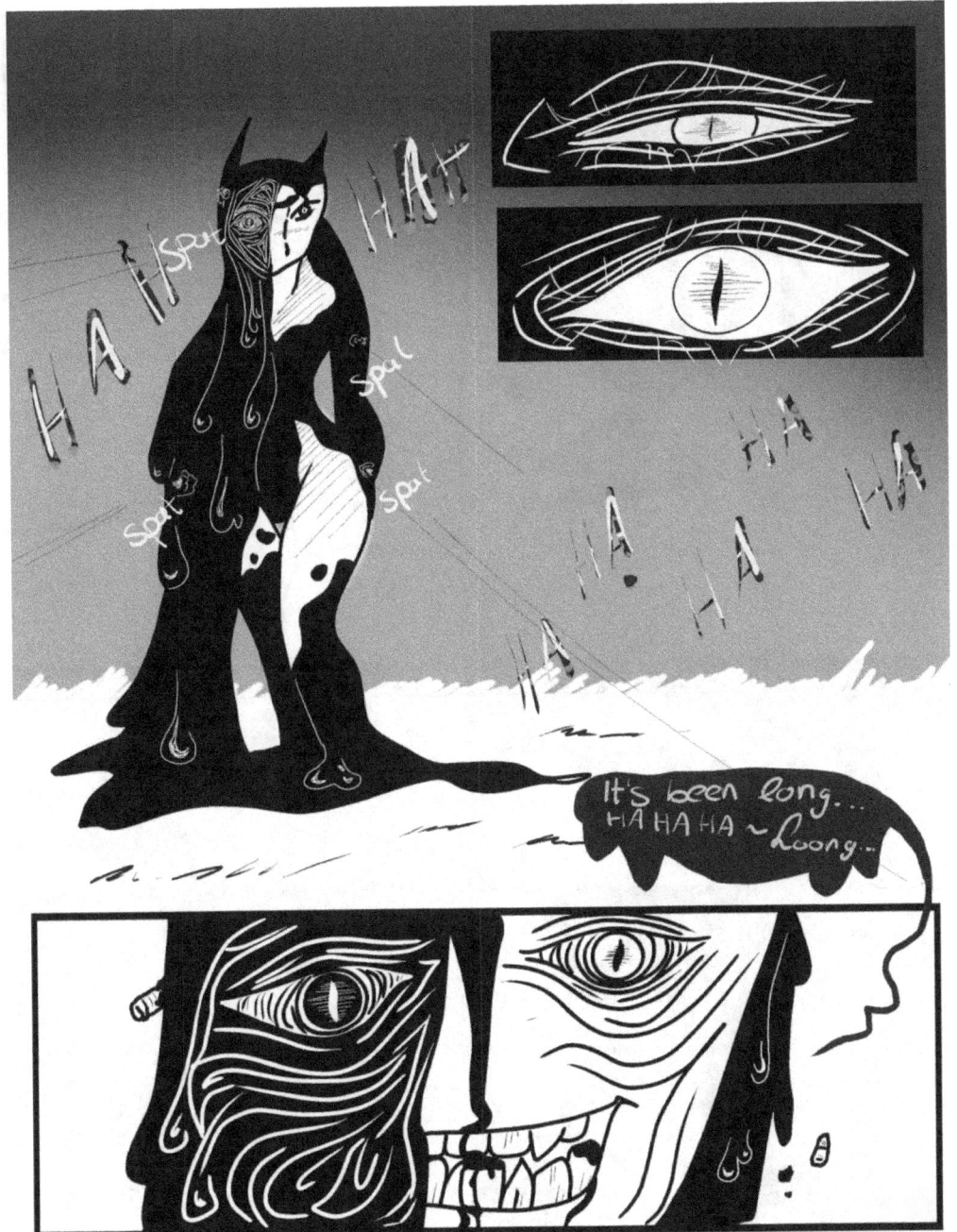

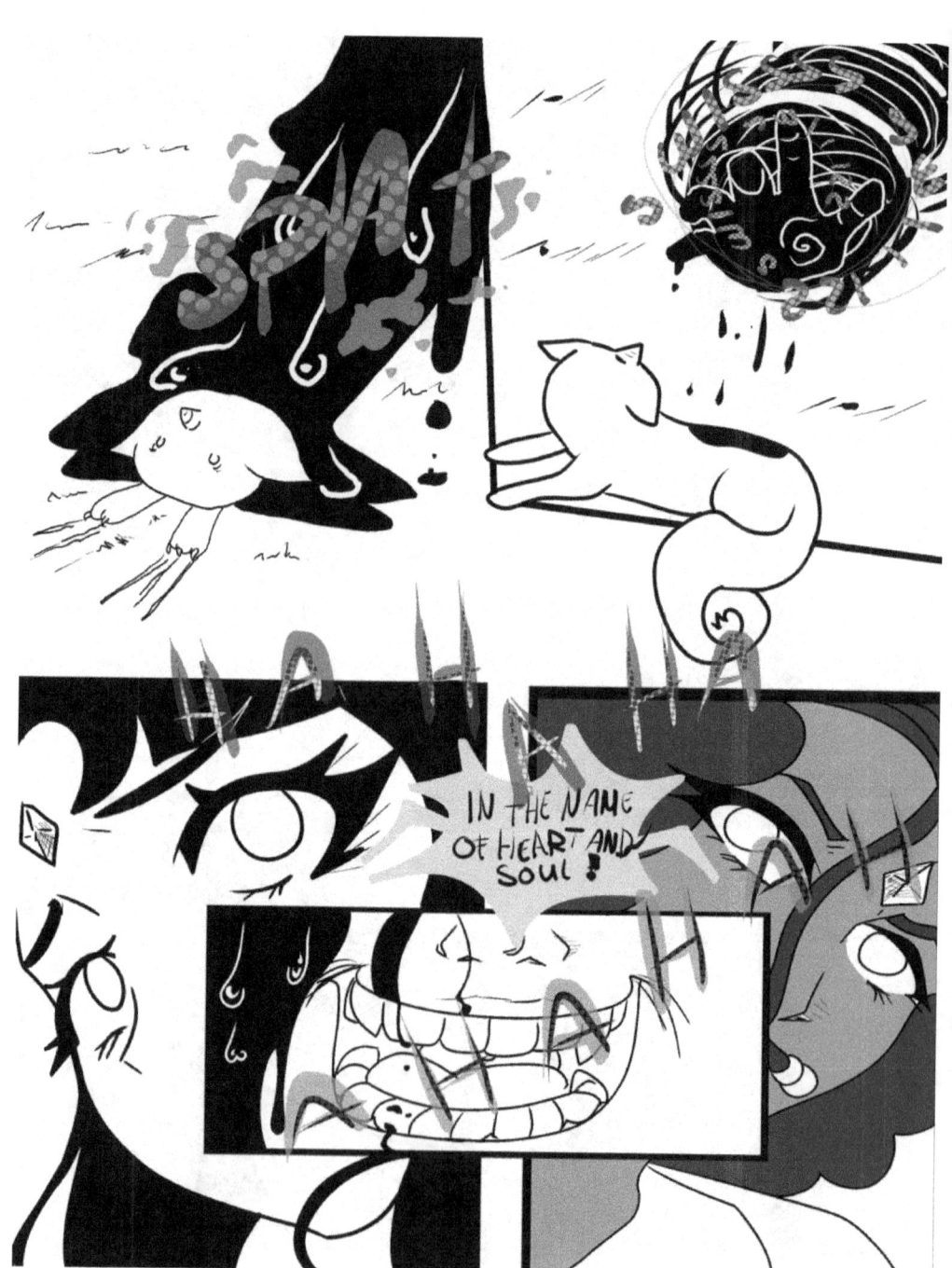

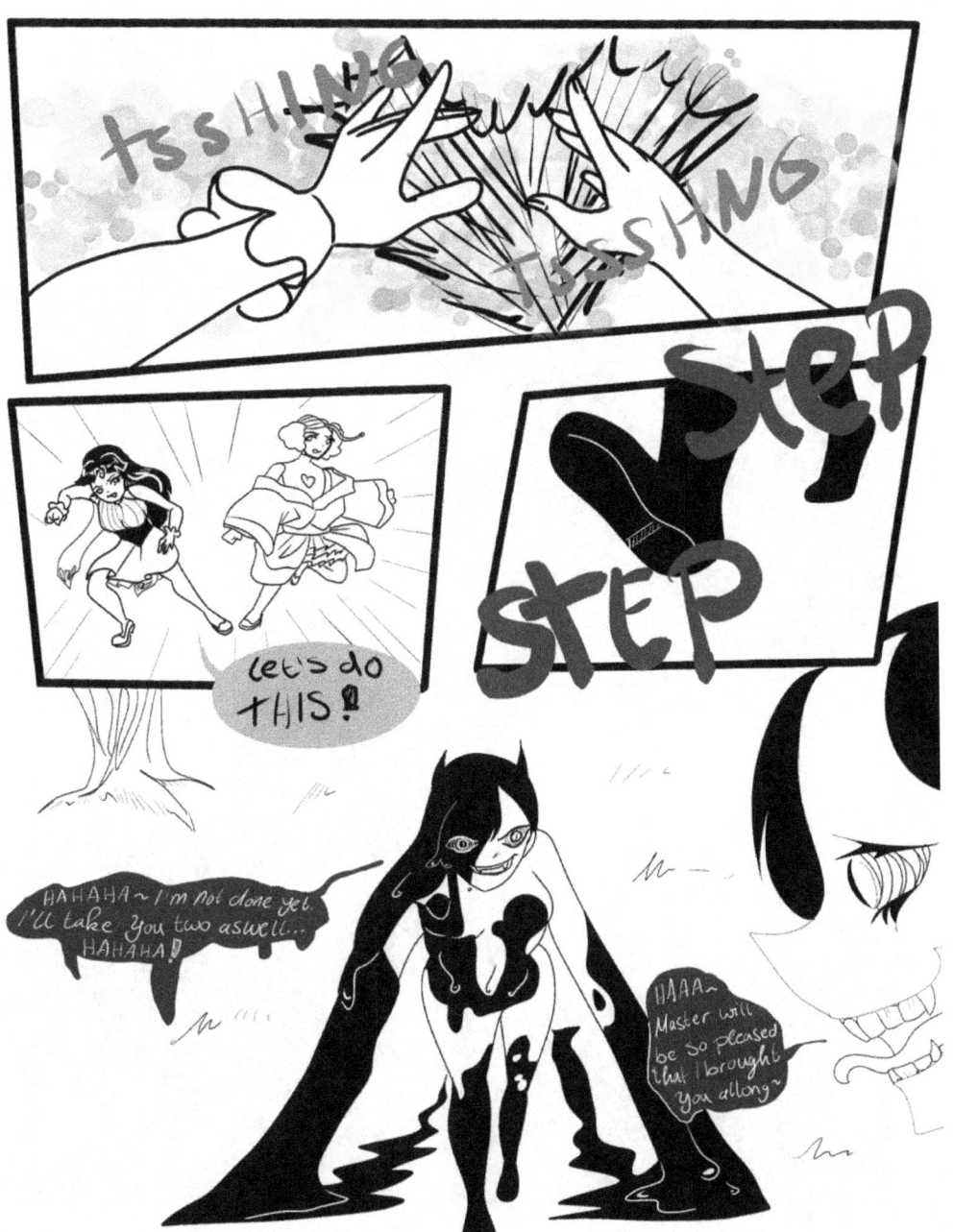

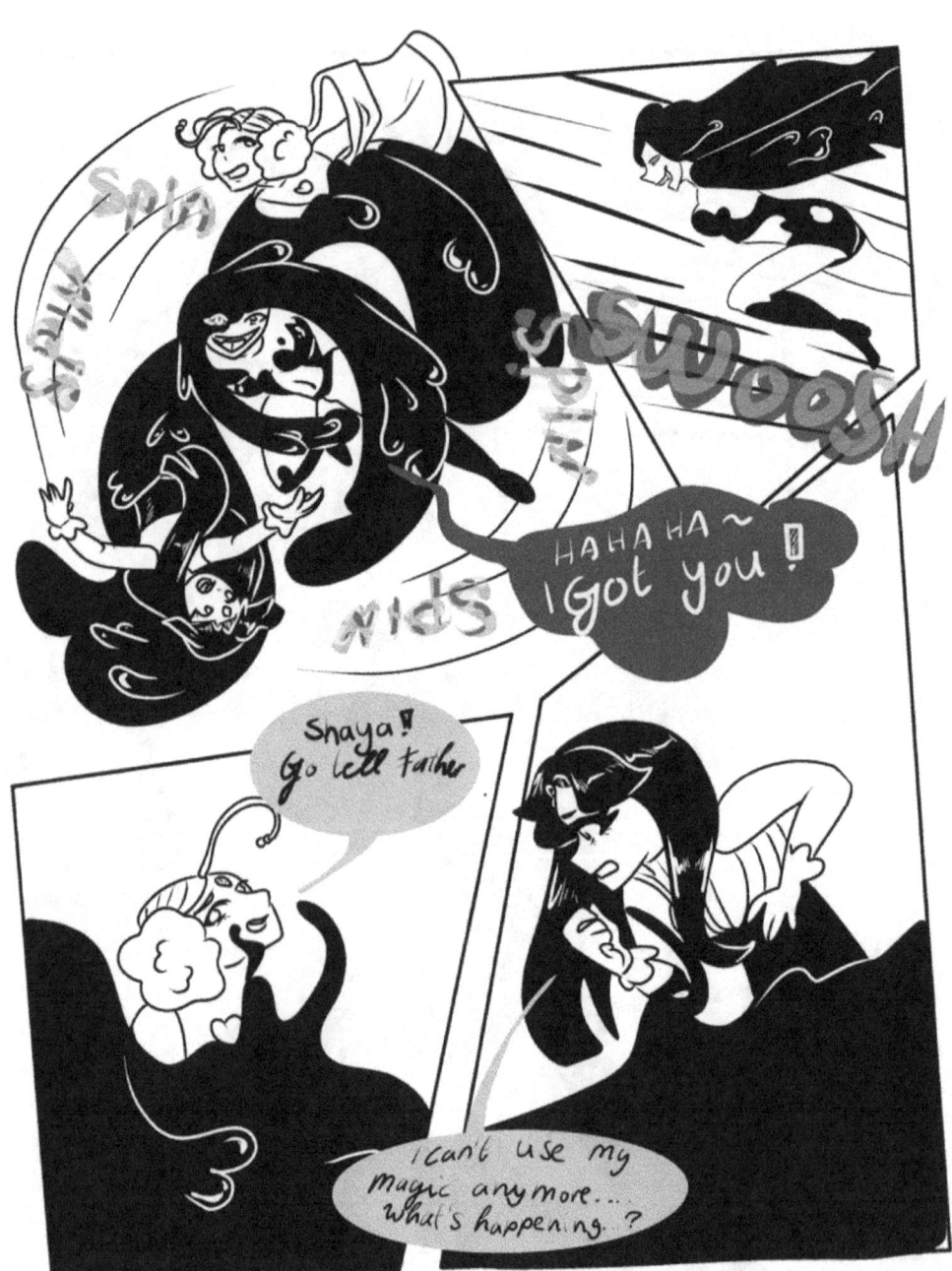

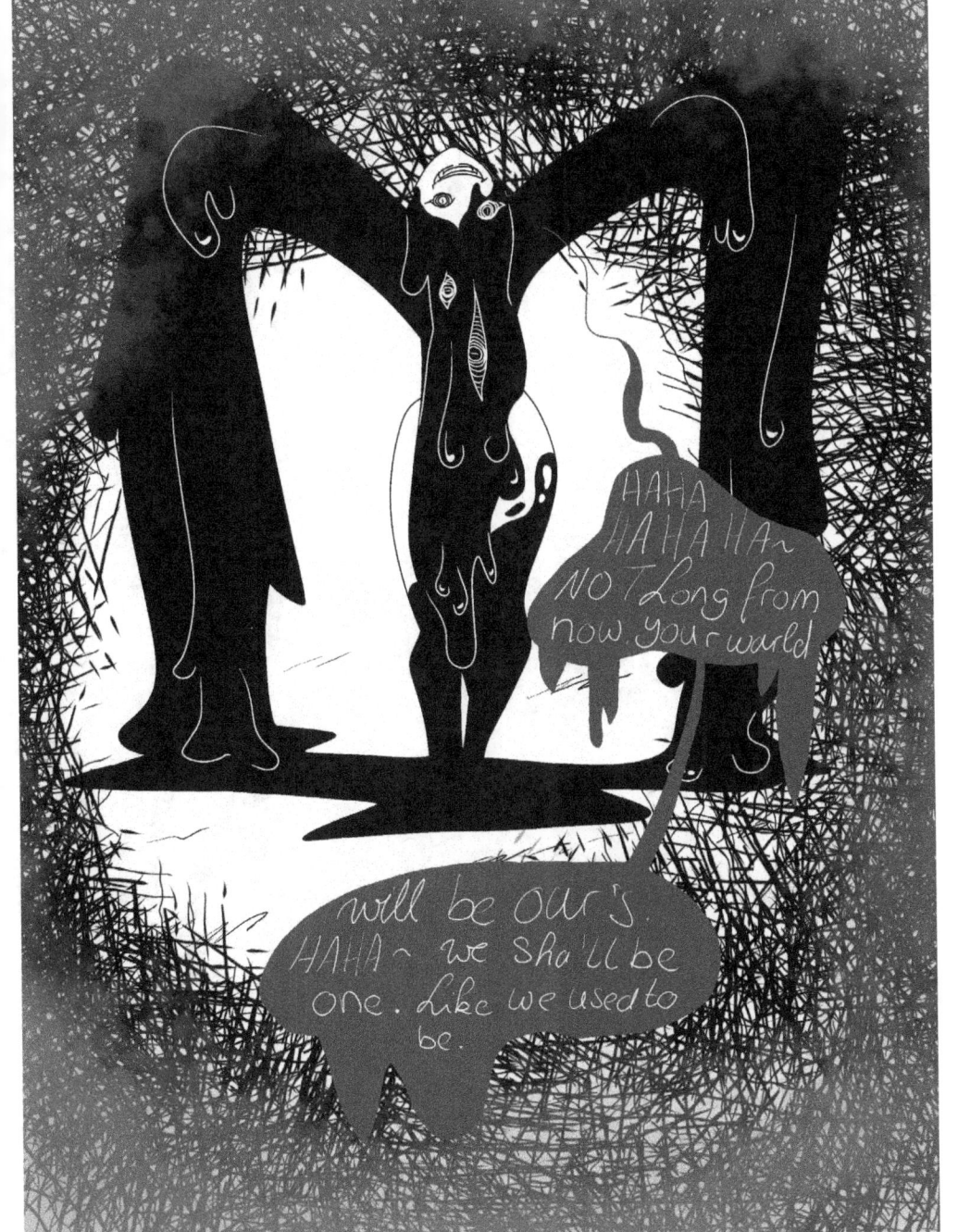

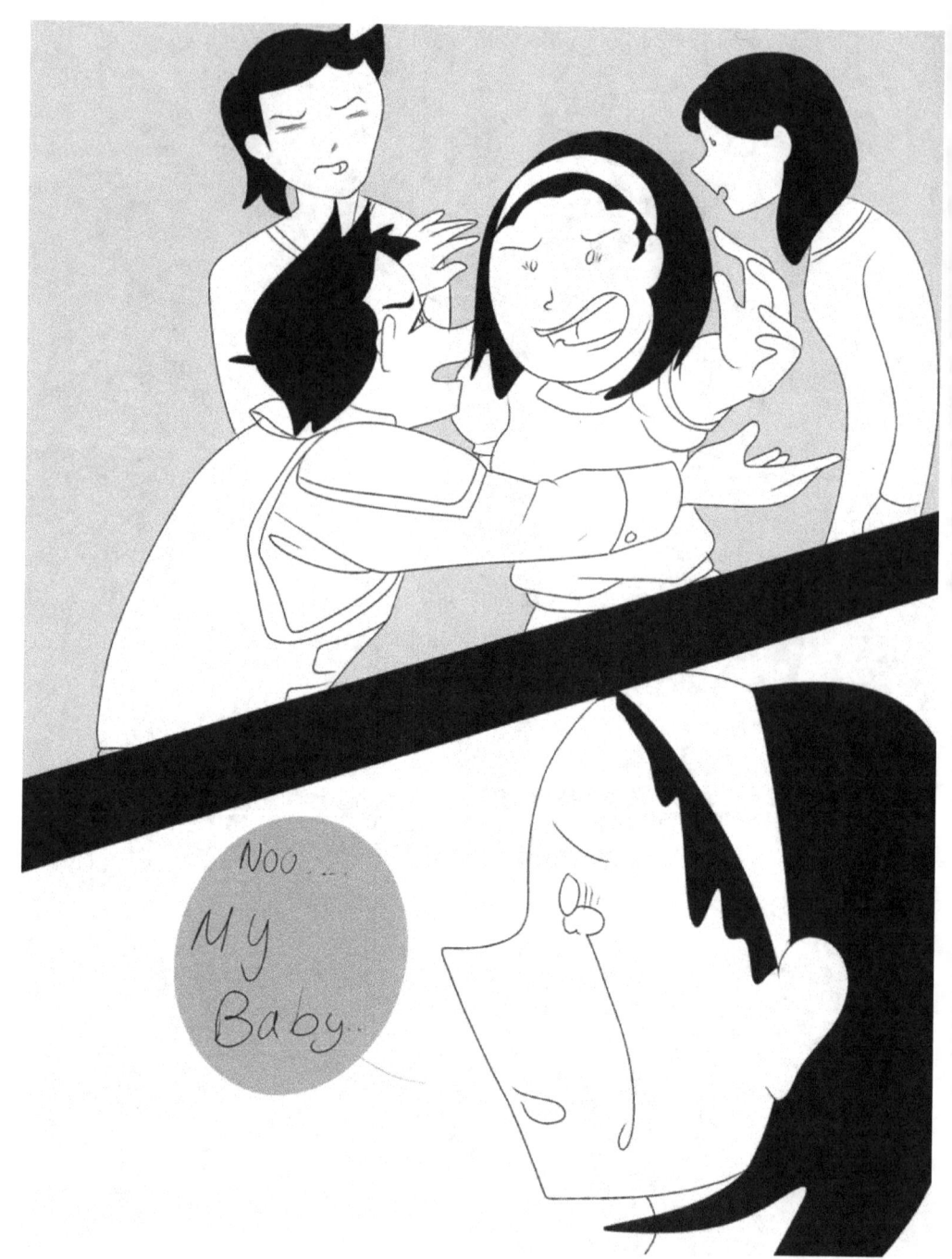

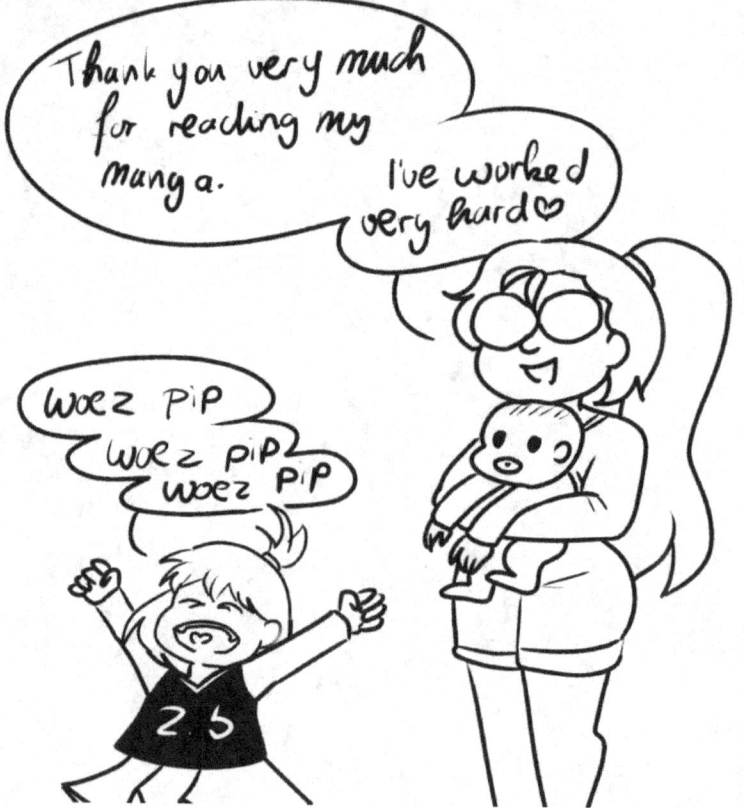

www.ingramcontent.com/pod-product-compliance
Lightning Source LLC
Chambersburg PA
CBHW070422240526
45472CB00020B/1152